ZOLTAN SZABO

Watercolor Techniques

D1308674

NORTH LIGHT BOOKS

CINCINNATI, OHIO

ACKNOWLEDGMENTS

The author wishes to thank the following friends whose contributions to this book's success are greatly appreciated.

Willa McNeill for her unconditional and enthusiastic help, support and encouragement. Greg Albert and Rachel Wolf of North Light Books for their untiring patience and editorial skill throughout the production of this little book.

DEDICATION

This book is dedicated to all my past, present and future students with the hope that this book will quench some of their thirst for knowledge and revitalize their love of watercolor.

ABOUT THE AUTHOR

Zoltan Szabo was born in Hungary and now resides in Charlotte, North Carolina. He travels across the country giving workshops and seminars on watercolor painting, and is the author of six watercolor books.

Zoltan Szabo Watercolor Techniques. Copyright © 1994 by Zoltan Szabo. Printed and bound in Hong Kong. All rights reserved. No part of this book may be reproduced in any form or by any electronic or mechanical means including information storage and retrieval systems without permission in writing from the publisher, except by a reviewer, who may quote brief passages in a review. Published by North Light Books, an imprint of F&W Publications, Inc., 1507 Dana Avenue, Cincinnati, Ohio 45207. 1-800-289-0963. First edition.

98 97 96 95 94 5 4 3 2

Szabo, Zoltan,
 Watercolor techniques / Zoltan Szabo.
 p. cm.
 Includes index.
 ISBN 0-89134-516-7
 1. Watercolor painting–Technique. I. Title.
ND2420.S93 1994 93-26801
751.42'2436–dc20 CIP

Edited by Rachel Wolf
Designed by Clare Finney
Cover illustration by Zoltan Szabo

METRIC CONVERSION CHART

TO CONVERT	TO	MULTIPLY BY
Inches	Centimeters	2.54
Centimeters	Inches	0.4
Feet	Centimeters	30.5
Centimeters	Feet	0.03
Yards	Meters	0.9
Meters	Yards	1.1
Sq.Inches	Sq.Centimeters	6.45
Sq.Centimeters	Sq.Inches	0.16
Sq.Feet	Sq.Meters	0.09
Sq.Meters	Sq.Feet	10.8
Sq.Yards	Sq.Meters	0.8
Sq.Meters	Sq.Yards	1.2
Pounds	Kilograms	0.45
Kilograms	Pounds	2.2
Ounces	Grams	28.4
Grams	Ounces	0.04

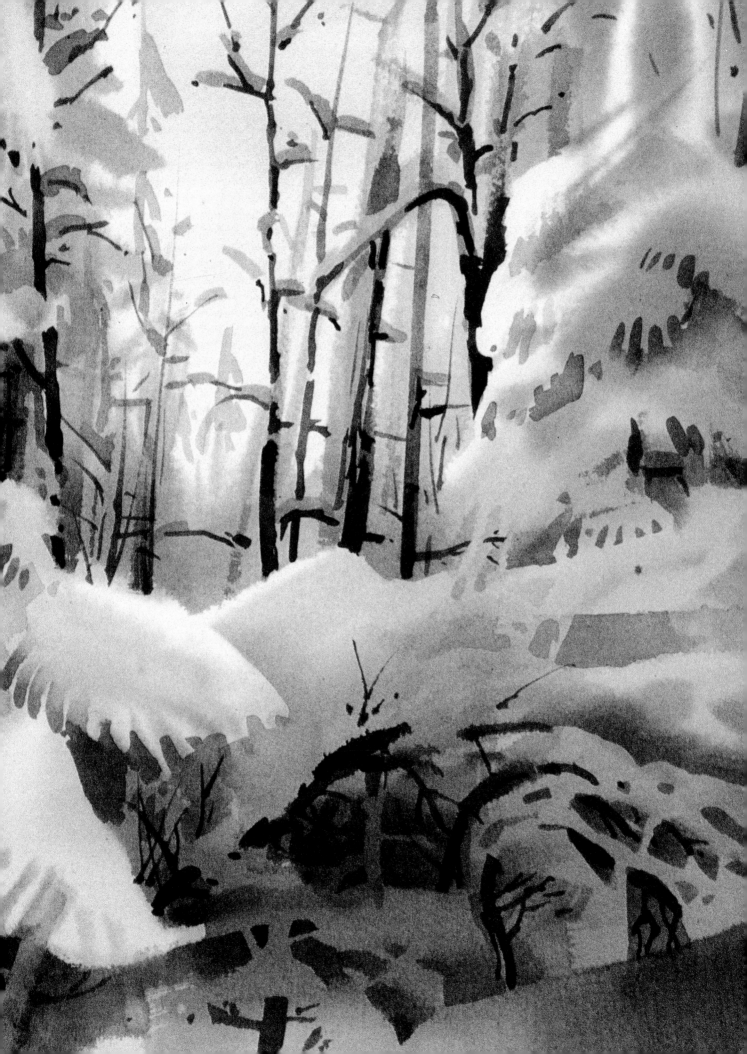

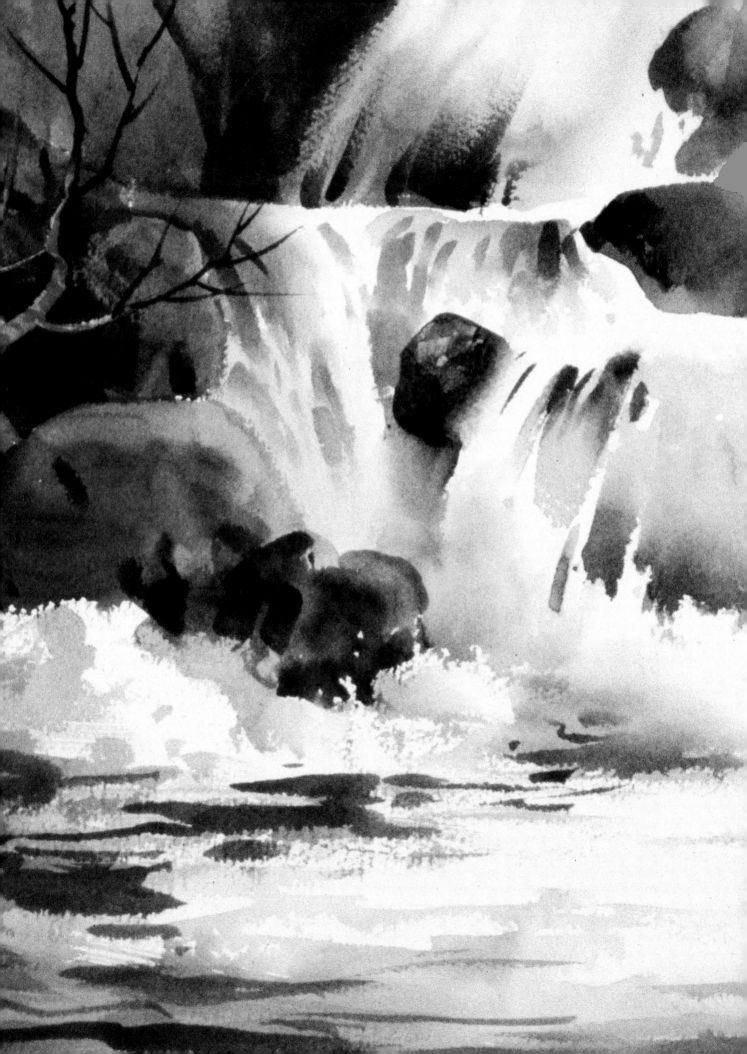

■ CONTENTS

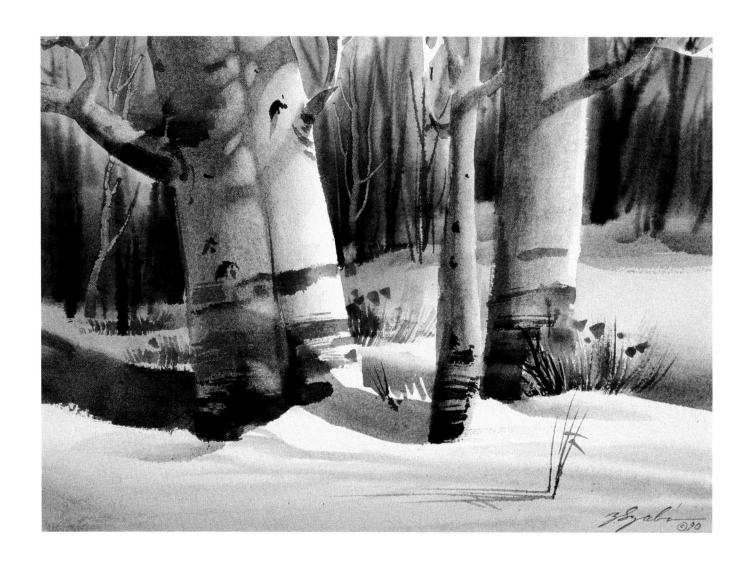

■ INTRODUCTION

HOW TO USE THIS WORKBOOK

This workbook is designed to help you master some of the subjects that have been the most requested in my workshops over the years. There are twelve projects, each of which focuses on a particular way of using watercolor; the methods and subjects are perfectly suited to each other. For each project there is a preliminary drawing that you can trace onto your own watercolor paper. You can practice each one as many times as you like, until you are confident in your new skills.

In this workbook I have also included some reference photos of subjects similar to those in the projects. I wanted you to try paintings of similar content, but different enough for you to have to make some creative decisions on your own. Drawings are also provided for these subjects opposite the preliminary drawings for the projects.

Each part of this workbook has been carefully designed for your benefit. It includes the introduction that you are reading now, twenty-four preliminary drawings as mentioned above, supplementary source photos, a page of close-ups of painting techniques and twelve projects. Each project has five pages.

MATERIALS AND TOOLS

Over the years I have developed and pared down my painting equipment to the basics. I use a small assortment of brushes, paints and miscellaneous equipment. Here is a list of all you need to complete the projects in this book.

Paper. Any good watercolor paper will do. I usually use Arches 300-lb. cold-press paper, but I will use others. I prefer heavier paper because it stays wet longer. On occasion I use a hot-press paper as well. Winsor & Newton makes a new paper that I have found to be quite good. I usually mount my paper on gator board, which is available at sign or frame stores and at some art supply stores. I tape the paper down with plastic-coated white artist's tape. This is easier to remove than masking tape, and I find it convenient sometimes to use the paint that is left on the tape to touch up small areas of a painting.

Each painting in the book was done on a 15" x 20" piece of 300-lb. cold-press Arches watercolor paper, from which I cut the watermark.

Palette. Any palette you find comfortable will do. The important thing is that the wells are slanted. This slows down drying on the palette because it leaves a smaller surface area for evaporation than a flat surface does.

Paints. I use mostly Winsor & Newton artist's quality colors but have found other good-quality paints. I use tube colors but not directly from the tube. I keep a generous amount of each color squeezed out on my palette at all times and work from the dried paint. I do this for economy. None of it gets wasted. Also, when you mix from wet blobs of paint, they both get polluted. With dry paints you just pollute the very top, which can be easily wiped off.

I preselect my colors for each painting based on either the colors in nature or an idea; sometimes a combination both. Then I make swatches of my color choices on a scrap of watercolor paper. I use only my selected colors and don't even wet the others.

My choice of colors is based not only on the hue but also on the nature or properties of the pigment—whether it is more transparent or reflective, staining or sedementary, etc. My colors for each project are listed at the beginning of Step One, where I also explain why I chose each color for that project.

Brushes. I use basically four categories of brushes: wide, flat, soft brushes to cover large areas; hog bristle slant brushes that I have designed especially for myself and my students for large shapes and special techniques; smaller (¾-inch and 1-inch) flat, soft sable or synthetic brushes for smaller glazes and dry brushing; and oil painting bristle brushes for scrubbing.

As far as I know there is nothing on the market like my Zoltan Szabo brushes, which can be ordered directly from me at the address on the next page. There are many advantages to using these brushes. They deliver large, dark shapes quickly, which is the secret to getting luminous darks. They can deliver a blended edge on one side and a sharp edge on the other with one stroke. They are available from 1-inch to 4-inches. For my soft, flat brushes I use the Richeson series 9010

from England, which has a razor-sharp edge. It is an in-between shape—softer and less snappy than the hog bristle (it doesn't seem to lose its resilience) but not as soft as the sable-type brushes. At times I use a long pointed rigger for detail. I keep a few separate brushes for losing edges and lifting color. They never touch the palette.

Painting Knife. Years ago I experimented and developed a technique for using a 2-inch painting knife for lifting light shapes like rocks off a wet, dark background. I also use the thin edge of the knife to paint branches and weeds with loose liquid color. (See page 3 for demonstrations of these techniques.)

Miscellaneous. I keep two water containers within reach at all times while painting. One is for washing out brushes and one is for drinkable clear water, used for losing edges, wetting the paper and other purposes.

I use lots of facial tissues. These are a must to have by your side while painting. I use these for blotting color when I am lifting, wiping brushes to keep them clean while scrubbing or while losing an edge, and many more things.

I make a brush blotter out of a roll of toilet tissue from which I remove the cardboard roll. I wrap the pressed-together roll with a lint-free white paper towel such as Bounty Microwave. I find that all of the water and color sinks down into the center of the roll, leaving the top clean to wipe my brushes on. Be sure to set this on a dish of some kind

to catch the water run-off. I use a plastic sandwich tray.

Once in a while I will use salt and a spray bottle for a special effect.

DOING THE PROJECTS

The first step for each project is to transfer the preliminary drawing to your water-color paper following the instructions below. Then follow the instructions step by step. Once you begin to paint, keep a scrap of water-color paper handy to practice any difficult passages before attempting it on your painting.

When you have completed each project to your satisfaction (you might want to do some of them several times), go on to the supplementary projects, for which I have provided you a source photo and a drawing only. I want you to apply what you have learned in your own way. The source photos are found on pages 64 and 65. The drawings for the projects and for the supplementary photo sources being on page 66.

Transferring the Drawing.
Prepare a piece of graphite tracing paper. Use a good-quality tracing paper cut to the size of your paper. Cover one side with graphite, using a soft pencil or graphite stick. Rub it with a tissue moistened with lighter fluid or rubbing alcohol until you have a fairly even coat. This can be used over and over again to transfer your drawings. Simply lay the prepared tracing paper face down on your watercolor paper and lay the printed drawing on top of that. Use some clamps, paper clips or tape to secure them. Then with a sharpened pencil, trace over the lines on the printed drawing using just enough pressure so that the graphite is transferred to your watercolor paper. If you make any smudges, erase them with a kneaded or plastic eraser.

SPECIAL TECHNIQUES

There are several special techniques I use in my workshops and also in this workbook. Some make use of my personally designed brushes, some use the painting knife and other brushes. On page 3, I show you some close-ups of these techniques, which should help you when you come across them in the projects.

SUPPLEMENTARY PROJECTS

As I said above, I have includ-ed twelve supplementary source photos. There is one which is the same general subject matter as each of the twelve projects. My intent is that you use the techniques you learned in completing the workbook project to paint a similar but different subject while making your own creative decisions. You will find these on pages 64 and 65.

You can order my slant bristle brushes from:
Zoltan Szabo
Watercolor Workshops
1220 Glenn Valley Drive
Matthews, NC 28105

For information on videos of these workbook projects, write to the same address.

Zoltan Szabo's slant bristle brushes in various sizes.

■ BRUSH AND KNIFE TECHNIQUES

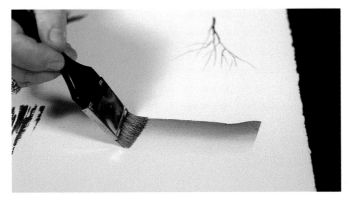

Lost-and-found edge brush stroke.
To accomplish this brush stroke, dip the long hair end of the slant edge bristle brush into color, and dip the short hair end only in water. Press and pull the brush sideways with a steady but even motion. The long edge leaves a sharp (found) edge, while the short end softens itself away (lost edge).

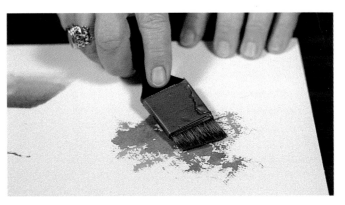

Wet washes with dry brush edges.
This foliage shape is painted with the flat side of the brush held as parallel to the surface as possible. Load the brush with a light, wet color and barely touch the surface of the paper to allow the edges to look lacy, like dry brush. Move the brush with a circular motion.

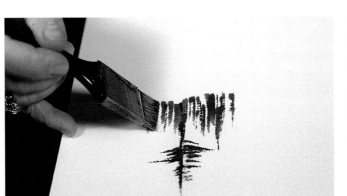

Edge contact strokes with the slant brush.
To make these coniferous foliage shapes, load the 2-inch slant bristle brush with color. Hold the handle upright with the long hair tip pointing to the bottom, the short tip toward the top. As you touch the paper, press harder at the bottom (long end), and raise the short end slightly off the paper. Repeat this stroke several times for vertical trees as well as for horizontal pine branches.

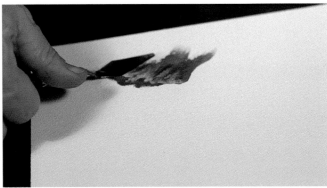

Knifing out light textures from darks.
To make a textured rock shape, brush on the shape with a medium wet wash. While this rich color is still damp, hold the knife handle with a firm grip, the tip pointed toward you and the wide heel upward. Press hard at the heel and relax the pressure at the tip. You should be squeezing the color off toward you, by simultaneously pressing down on the far edge and lifting the near.

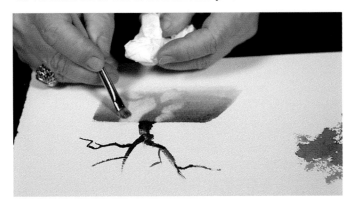

Lifting color from dry washes.
First, make sure you use a nonstaining color. Use a firm, moist bristle brush. Scrub out the areas you want to be light, keeping a clean tissue in your other hand for wiping off the lifted color. If you forget to wipe off your brush, you will scrub the color back into your paper. Here I left the original wash for the tree's shadow.

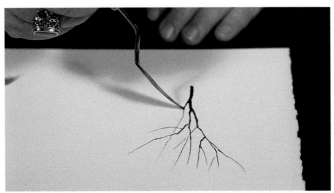

Painting lines with a palette knife.
The palette knife is great for painting tree shapes. Dip the knife into liquid color and hold it upright. Touch the paper at the bottom of the tree with the flexible point of the knife and drag it up slowly. As the blade loses color, the lines get gradually thinner and lighter.

■ PROJECT 1: ICICLES

Winter icicles are a challenging subject matter because they usually offer high contrast with the rocks around them. The rocks are luminous darks and are textured with the palette knife. The icicles are made up of many colors:

Antwerp blue. A luminous blue with a hint of green that is preferable to Winsor or Prussian blue. This color fluctuates; it fades some in the light but recovers in the dark.

Raw sienna. A transparent, neutralized or low intensity yellow; a sedimentary pigment; when mixed with Antwerp blue it will make a useful dull green.

French ultramarine blue. A second, warmer blue for the background; French ultramarine blue makes a dull gray when mixed with raw sienna but a really beautiful gray with burnt sienna.

Burnt sienna. A neutral, transparent orange that is amenable to the texturing we will do on the rocks.

Sepia. A dark staining color that will be useful for texturing the rocks.

Permanent rose. An intense, primary red that is very transparent; useful for warm accents. It is not too strong but holds its own in mixes so it sparkles through when dry.

STEP ONE

Wash In Icicle Shapes:

1. Start on dry paper. Elevate the top of the board about an inch. Make some light washes to represent the icicles using the soft 2-inch brush and a diluted mixture of raw sienna and Antwerp blue. Flip the brush down toward the bottom of the paper. The brush should just be moist with the color so the white of the paper will sparkle through. You can lift some color unevenly with a damp, clean brush (a thirsty brush) to define some softer edges.

Remember that the color will dry a lighter value than it looks when it is wet. Add some darker values to the still-wet color and let it blend for variety. Your aim is harmony between color and value so the color will not be boring.

On dry surfaces, wet strokes dry unevenly. Use the corner of a small 3/4-inch flat brush to give the icicles some secondary modeling. Use a darker mixture of raw sienna and Antwerp blue to add some darker tones on top of the lighter and to indicate detail. Use clean water and a bristle brush, wetting and scrubbing areas to model soft edges. Don't worry about the edges too much, since you will use darks later to

modify and clean them up and to get a more interesting variety of shapes. Let the painting dry.

2. Add French ultramarine blue to paint the lower icicle shapes and use a thirsty brush to soften the edges. Vary the mixtures of the three colors—raw sienna, Antwerp blue and French ultramarine blue—to make it interesting. Add a touch of permanent rose for a slightly violet dark. Model with a grayed mixture of raw sienna and French ultramarine blue. You are not painting icicles, rocks and snow, but shapes that suggest these things!

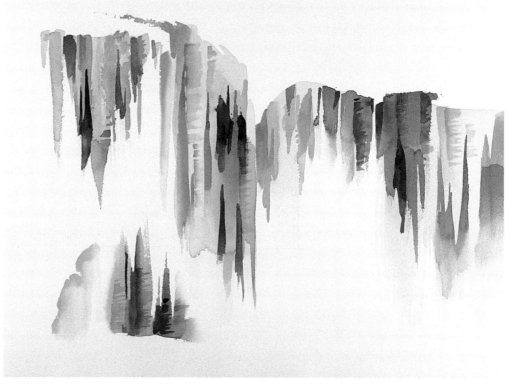

Antwerp blue Raw sienna French ultra- Burnt sienna Sepia Permanent
 marine blue rose

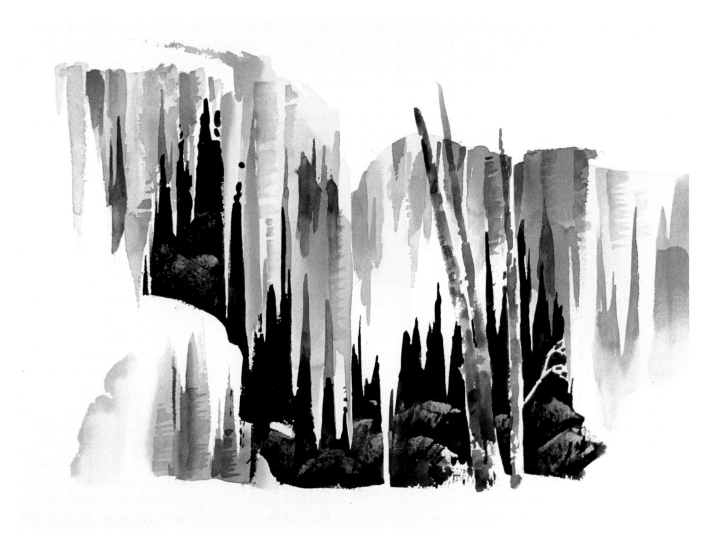

STEP TWO

Add Darks:

1. Most of the basic shapes have been established. Look from spot to spot, making adjustments as necessary. Save whites. Keep in mind where you are going to put the foreground tree. To make the translucent ridges and fluting on the icicles, add color to one corner of the flat brush and dab on.

2. Make a dark mixture of permanent rose and burnt sienna and dry brush the approximate dark shape of the rocks, leaving white to suggest snow stuck on the surface.

Paint the tree now to save it from being overpainted later. Leave white sparkle to suggest snow. Add hints of red and blue to the color to add interest. Build up contrast in back and define white in the foreground.

3. Mix Antwerp blue and sepia and glaze onto the wet darks for greatest contrast. Use the palette knife to texture the wet paint when the paint is tacky—not dry nor drippy. Hold the handle pointing toward the light, and push the heel of the knife down, across the paint. Use the knife right away so the paint has less time to stain the paper. Use a brush to clean up the edges (see page 3).

Add permanent rose and burnt sienna touches in the color. Press hard with the heel of the knife. Add more background darks to create positive icicle shapes by painting around them.

Just because it is dark doesn't mean that it has to be boring.

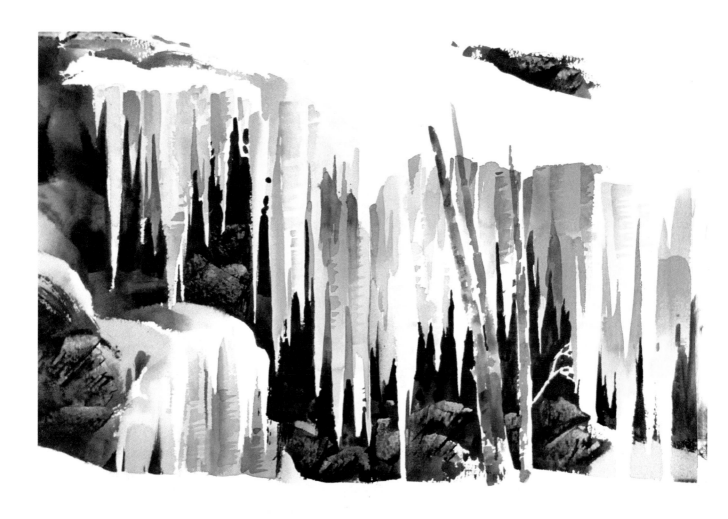

STEP THREE

Continue Modeling the Dark Rock Shape:

1. Use a large, 2-inch bristle brush to pull out lights. Don't get picky at this point. Use the slant brush by dipping the corner into paint with clear water on the other side so a single stroke will make a blended tone from light to dark (see page 3). Vary the dominance in the color. Add a new group of shapes, blurrier but relat-ed to the knifed shapes made in the previous steps. Force the viewer's eye into the center. Create a jagged line that becomes the edge of the icicles. Using sepia and Antwerp blue for your darkest dark, turn the brush to create soft and hard edges.

2. Next, neutralize the snow color on the left with a grayed blue mixed from French ultramarine blue, Antwerp blue and burnt sienna. Add some darker touches to the ice flow on either side to keep the con-trast in the center. To keep the glare of the white snow in the center from being too strong, reduce it a bit as well so it is not blinding against the darks.

3. Add a dark rock shape in the snow at the top with a dry brush stroke. It should have a broken edge on the top and a hard edge along the bottom.

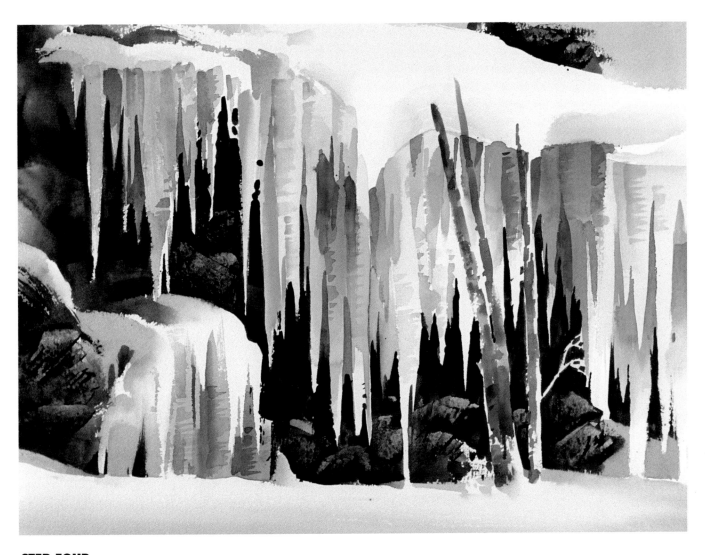

STEP FOUR

Model the Snow:

1. Model the snow with a basic gray made from French ultramarine blue and burnt sienna; apply it with a bristle brush (paint on long hairs, wet on short). Define the white with a blended edge. Add more modeling with Antwerp blue, raw sienna, and touches of the icicle color.

Clean your palette frequently to avoid polluting your color mixtures.

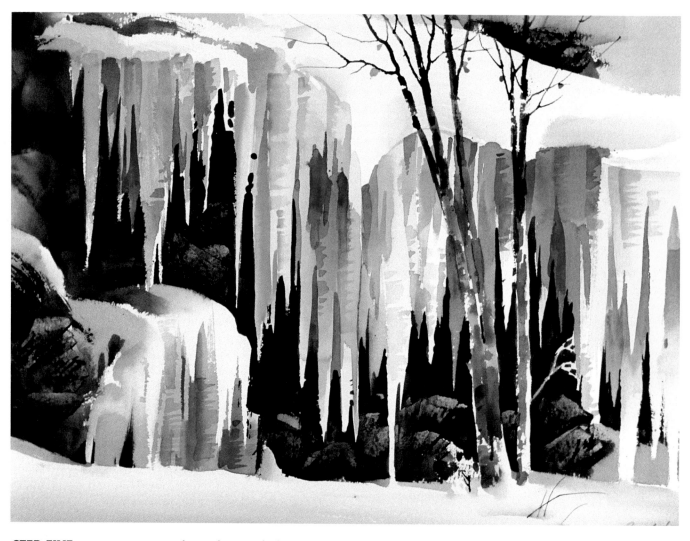

STEP FIVE

Finish the Trees:

1. Finish the trees by expanding the finer branches with the palette knife dipped in a liquid mixture of burnt sienna and sepia (sepia alone is too dead) and a little permanent rose (see page 3). The knife must be clean to readily pick up paint. Use toothpaste to remove any grease from the blade. Use the edge of the blade to scrape the wider branches and the tip for pulling out twigs. Don't pick it to death. (Accidental textures are the most interesting—any irregularities in the knife lines can suggest the location of the next branch.)

2. Near the bases of the tree trunks, add what architects call "growies"—the small weeds and shoots that grow there. Little touches add texture.

Ice Cave
Zoltan Szabo 15" x 20"

■ PROJECT 2: AZALEAS

The subject of this painting is a group of sunlit azaleas. Although it was inspired by a reference photograph of the flowers, it is a free interpretation, not a copy. I was attracted by the opportunity to use luminous, transparent colors and by the possibility of working with the almost abstract, organic shapes of the flowers. Bright, clear, high-intensity colors are the glory of watercolor, regardless of the subject or painting style. I chose the following five colors for my palette because they enabled me to produce a rich, luminous background and glowing, transparent colors on the flower petals:

Cobalt violet. A transparent color that sparkles and glows. It is a sedimentary color that is lifted easily—it does not stain.

Cobalt blue. A permanent, transparent color that also lifts easily. However, it cannot be darkened.

Antwerp blue. A transparent color that is naturally dark and will be useful in making rich, colorful darks.

Burnt sienna. A neutral orange. It is a transparent earth color that is very strong and can be overpowering if not used with care.

New gamboge. A transparent staining yellow that will make a brilliant green mixed with either blue. It is useful for warming up burnt sienna and cobalt violet.

STEP ONE

Soft Gentle Flower Shapes:

1. First wet, but do not soak, the surface of the paper using the soft wide brush. Then use the 2-inch wide bristle brush to apply cobalt violet in bold, firm strokes to the right of center. Because the color settles so quickly, continue to apply the color with each brush touching the edge of the previous one. Add some cobalt blue and stroke it into the wash. For the flower in shadow, use bold strokes of a rich mix of cobalt blue, cobalt violet and Antwerp blue.

2. For the leaves, make a green from new gamboge, cobalt blue and cobalt violet. Stroke it on while the paper is still wet. Add more and more color while adding less and less water to the mixture. The green in the shade under the center flower is a bit darker. Use the green to establish the edges of the white shapes of the flower in sunlight.

3. Mix a deep violet color from Antwerp blue and cobalt violet for the inner part of the azalea. The blue and violet retain their individual identities in a mix and give the wash its unique character.

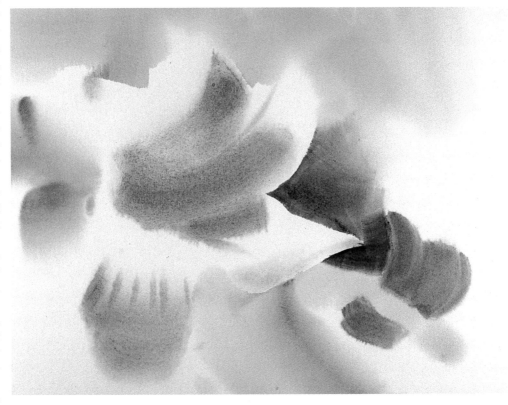

Cobalt violet Cobalt blue Antwerp blue Burnt sienna New gamboge

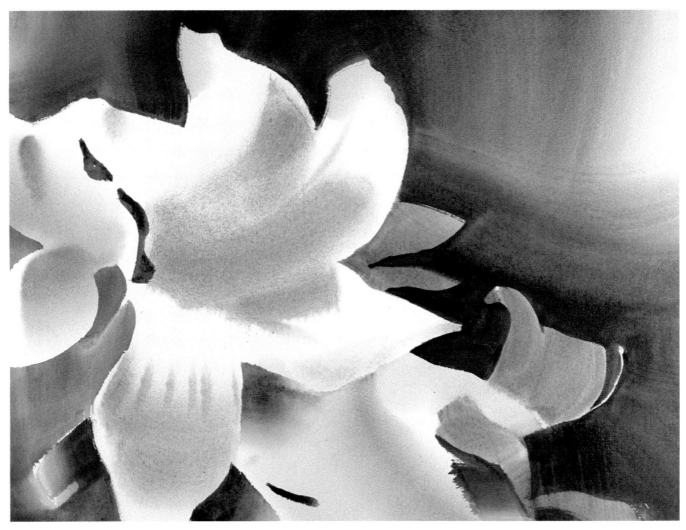

STEP TWO

Dark, Loose Background:

1. Mix a neutral color with cobalt violet, Antwerp blue and burnt sienna. Paint the background to define the edges of the petal shapes with the 2-inch slant brush. Use curvilinear brushstrokes to pick up the rhythm of the petals. Then use sweeping strokes from left to right, adding more cobalt violet toward the right. Suggest shapes in the background, letting the strokes retain their identity. Don't overblend.

2. Add some burnt sienna to the lower right corner. To create some variety, add some deep darks made with burnt sienna and lots of Antwerp blue. The color should be rich and strong. Remember: *Get in and get out.*

The dark shapes will dry lighter than they look when they are wet. Use a strong green for the lower left. Any white sparkles are left as is. Add a touch of cobalt violet into the green for interest.

The shapes of the flowers will be enhanced by the application of the dark shapes next to them. Use the point of a small brush to refine the petals.

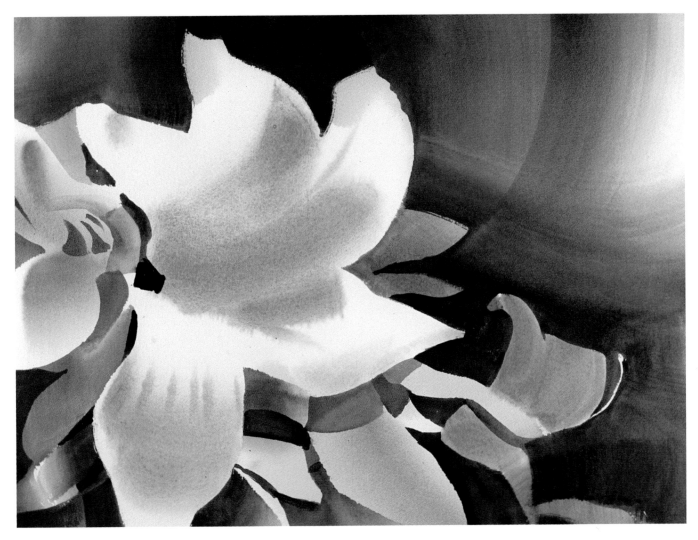

STEP THREE

Cast Shadows:

1. Use cobalt blue for the cast shadow on the leaves beneath the large flower. Create the shape of the leaf by painting the darks around it.

2. The background has one job: to make the center of interest look better. Use more dark burnt sienna and lots of Antwerp blue to define the shapes to the left of the flower. Add darks to the lower left corner and some cobalt touches in the upper left of the picture.

3. Add some almost pale green under the center of the large azalea. Paint the stems and leaves that are there by painting the negative shapes with medium-value greenish blue.

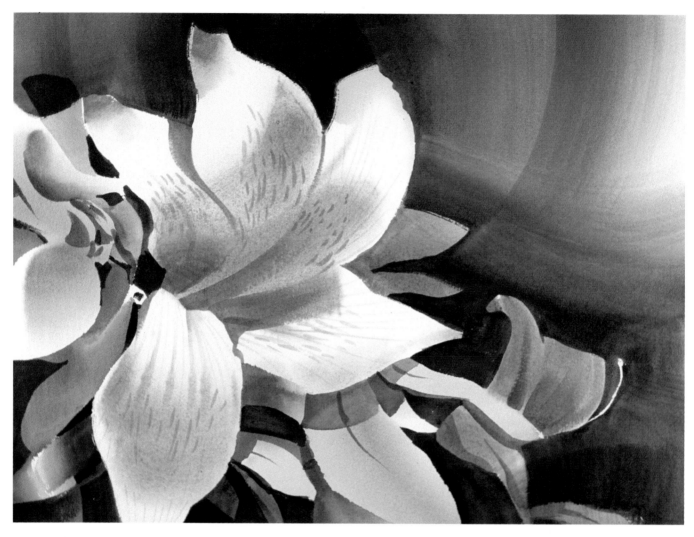

STEP FOUR

Flower Details:

1. Clean your palette. Paint the detail in the flower with cobalt violet and cobalt blue. Use what I call "hit-and-run strokes," where you apply the paint once and don't go back. Define the back petal with a 1-inch or 3/4-inch synthetic flat brush.

2. With the short brush, define the center of the flower. Link the lower petal to the top with some cobalt blue and cobalt violet. Use Antwerp blue and raw sienna to create the structure of the stem.

3. In the upper left corner, use cobalt violet and a little burnt sienna to extend the sweep of the petal curve for an almost abstract manipulation of the background. Add the center lines of the leaves.

4. Add dark green to the upper left corner. Apply a glaze of cobalt violet and burnt sienna for the warm accents on the leaves at left and the stem on the bottom.

5. Add more calligraphic texture with lots of cobalt violet and a touch of burnt sienna painted with a rigger. Paint the "freckles"—the dots on the petals—with the tip of the small round rigger brush.

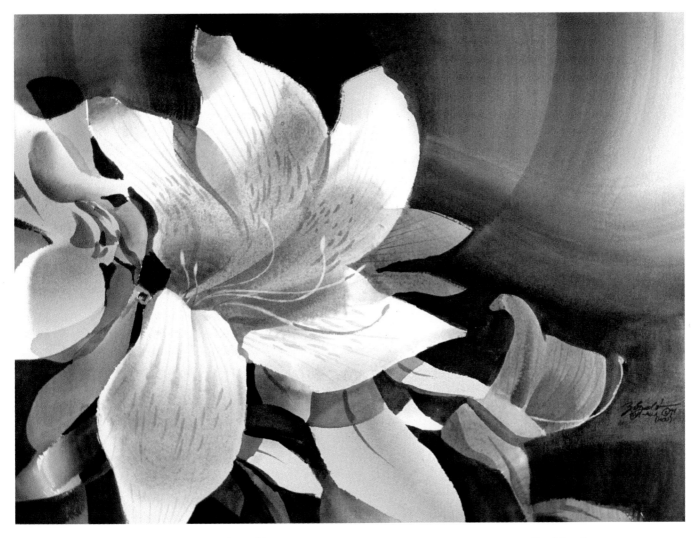

STEP FIVE

Stamen and Finishing:

1. Lift out lines for the stamen on the little flower on the right with a worn-out number four oil paint brush. Scrub out the throat of the flower. The cobalt colors will lift out easily. Pull out the stamen lines, which cross randomly. Use tissue to blot the lifted color from the paper. Then use color to make positive lines for the stamen where it is dark against the white flower.

Paint the white stamen on the far right by painting around it.

2. Finally, paint the overlapping shapes to hint at the transparency of flowers where the petals overlap.

Paint some finishing touches, such as the pink lines on top of two petals, and block in the shadows on the bluish center petals. Keep the texture subdued. Darken below the center flowers with Antwerp blue and burnt sienna.

Loud Speaker
Zoltan Szabo 15" x 20"

■ PROJECT 3: MOONLIGHT ON SNOW

The most effective way to get the beautiful softness of moonlight on snow is to make use of watercolor's wonderful ability to lift off the paper after it has dried. But there is one crucial element in planning this kind of painting that cannot be ignored. You must know your pigments well and choose only nonstaining colors for the area you will be lifting.

The following three color choices are nonstaining colors and will lift to pure white to carve out the shadows:

Manganese blue. A little garish by itself, but good for the greenish color of moonlight mixed with the other colors.

Aureolin yellow. Tones down the manganese blue.

Cobalt violet. This neutralizes the manganese blue and aureolin yellow mixtures.

The following four staining colors are for rich darks:

Sepia. The darkest color on my palette. It is to be used with restraint and rarely, if ever, alone. Goes very dark.

Thalo or Winsor green. To be used with sepia for a cooler neutral dark.

Burnt sienna. Use with sepia or other colors for a warm sparkle in the darks.

French ultramarine blue. A nonstaining color that can be lifted to near white for the areas of snow that need a darker shadow. *Don't wet the paper. When the paper is wet even nonstaining colors seep in and are hard to lift.*

STEP ONE

Shadow Wash and Darks:

1. Mix lots of manganese blue and cobalt violet with a little aureolin yellow. Test the color on a small piece of watercolor paper. Make sure it is dark enough. I found it necessary to add a little French ultramarine blue. This means that I will not be able to lift all the way to a paper white, but the stronger dark will mean greater contrast. Be sure to mix enough color.

2. To wash in shadow tone, tilt the board slightly toward you. (An inch elevation will do.) With a large (1 1/2-inch to 2-inch) soft brush, starting about one-third down from the top, quickly cover the dry paper with the mixture you just made. Carry your brush strokes all the way through from side to side. The color will get lighter as it gets closer to you, toward the bottom of the page. Add more color if necessary, starting again at the top of the page and following through with your brush strokes.

3. While your wash is drying, begin the background darks at the top of the page. Using French ultramarine blue and burnt sienna with a bristle brush, cover the background with vertical strokes of color. As you paint, vary the color from warmer to cooler. Add a bit of Winsor green in some places. Watch for vertical shapes appearing in the darker values because of the bristles of your brush. They may resemble trees and other foliage.

4. Go back and add more tree shapes, making use of the "accidental" shapes your brush has made. For these vertical dark strokes you can use the edge of your wide bristle brush or a smaller brush. Use sepia mixed alternately with burnt sienna and Winsor green. Bring some of the strokes down to reach into the middle ground. When the darks are almost dry, brush some aureolin yellow across the central area where the light will be coming from.

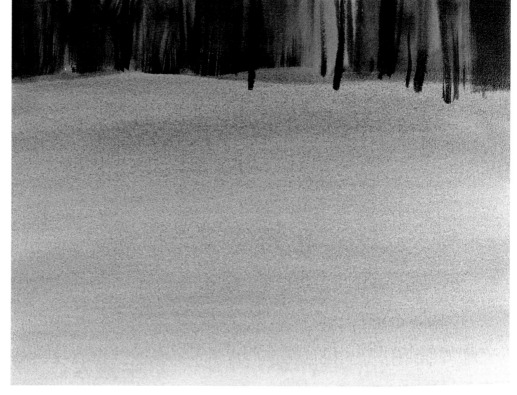

Manganese blue Aureolin yellow Cobalt violet Sepia Winsor green Burnt sienna French ultramarine blue

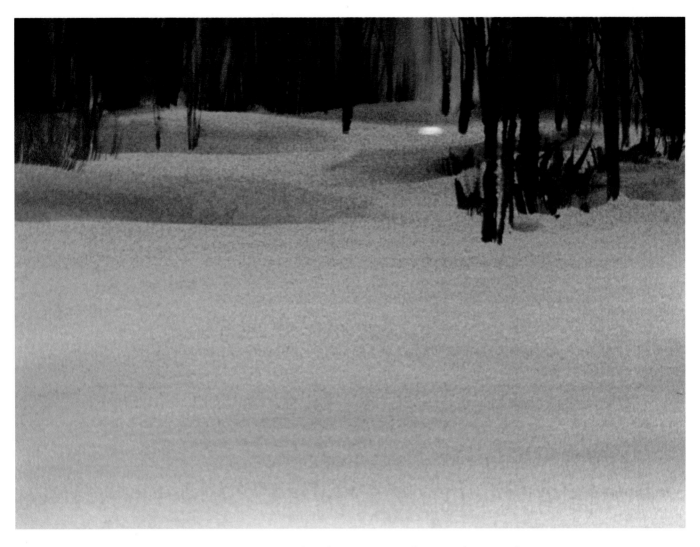

STEP TWO

Complementary Dark
Shapes:

1. Before you go any further, make sure your colors will lift off. Some papers don't respond well to lifting. With clean water and a small brush, lift out a small amount from an area you know you will need to lift. If the color doesn't lift to your satisfaction, you may need to start over on a better paper.

2. Add dark positive tree shapes in the background both for composition and to describe the subject more fully. Use sepia with either burnt sienna or Winsor green. Make sure some of the tree shapes overlap the manganese wash. *Rich, deep value is very important.* This area also acts as a complement to the cool blue shadow color, so be sure to keep it on the warm side. Add some variety to the tree shapes with a small rigger, giving the illusion of light and dark branches. Make sure the two sides balance but aren't equal in volume and design.

3. When the background is dry, create the humps of snow using a mixture of French ultramarine blue and aureolin yellow. Make quick strokes with a 3/4-inch brush at the base of the trees. Lose the top edge immediately by a quick stroke with a clean, thirsty brush. Add drama with more variation in the ground level using the self-blending slant bristle brush. Apply color only to the long hair tip and keep only clean water on the short bristles. Then as you make your brush stroke, it will blend its own edge toward the short hair end.

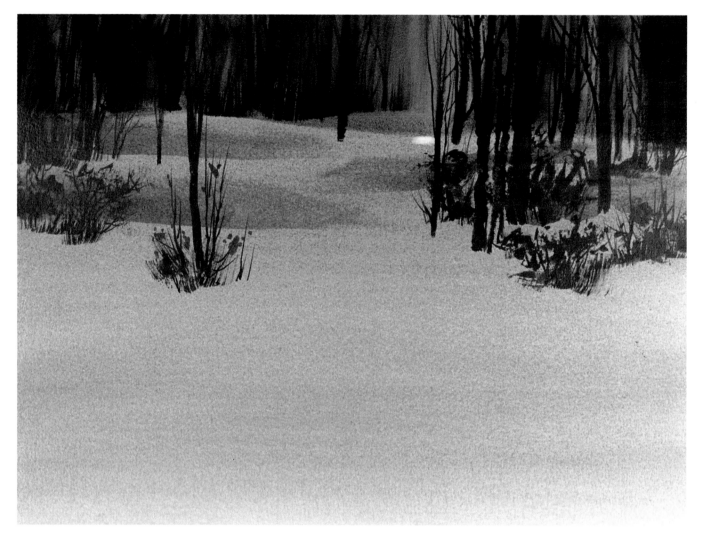

STEP THREE

More Darks in Middle Ground:

1. Using the 1 1/2-inch slant brush, make more dark middle ground shapes. This will break up the monotony and will create a cause for the effect we are going to make: shadows on the snow. Again, use the dark sepia varied from warmer to cooler when mixed with burnt sienna or Winsor green. To establish the clusters of dark mass, you need to use lots of paint and very little water.

2. Drop in a few individual twigs or branches with a small rigger to make the clusters interesting. Use a little bit of pure burnt sienna for highlights for what appear to be warm, illuminated leaves.

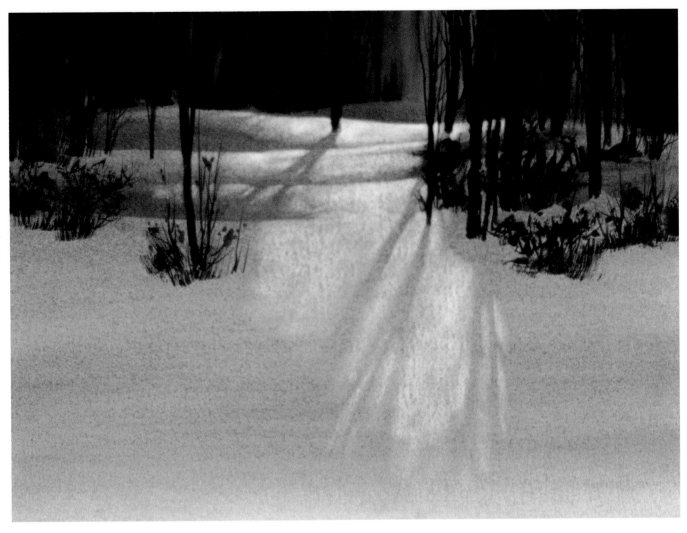

STEP FOUR

Lift to White for Moonlight:

1. In this step you will be lifting the color to create the glow of moonlight. At the same time, the dark shapes you leave will create shadows that will flow from the trees and ground trees. Remember, you are not lifting the shadows, you are lifting the light. Work slowly, continually checking that your shadows are extending logically from the dark foliage. Protect the integrity of the shadows by making the white patches islands—the shadows should be continuous.

2. For your lifting technique, use a few different sized old bristle brushes that have not been used for oil paint—the more worn out the better—and a box of paper tissues. Using a fair amount of clean water, scrub a small area you want to lift and blot immediately with a tissue. Keep changing tissues so the color doesn't get pressed back into the paper. Don't rub the paper with the tissues.

3. To lift a small area to very white, hold a small brush firmly and use lots of water, blotting with clean tissues. As soon as the pigment is loose, blot it. For larger areas that do not need to be as white, use a larger brush pressed less firmly and scrub more quickly. Switch brushes to vary the amount of color lifted and to vary the edges.

4. If you accidentally touch a middle ground dark shape with your scrubbing brush, blot it off right away before it has a chance to contaminate the shadow color. You can reapply the dark after the area is dry. It is better to lift too little than too much.

5. Start at the rim where the light is brightest. Use lots of water in your brush. Scrub horizontally with a small motion. Continually stop and look to get your bearings for the placement of shadows. The shadow edges should vary from sharp to blurry—sharp where the object is close to the surface, blurry where it's far from the surface. Shadows taper toward the light source. Elevation will mean a value change.

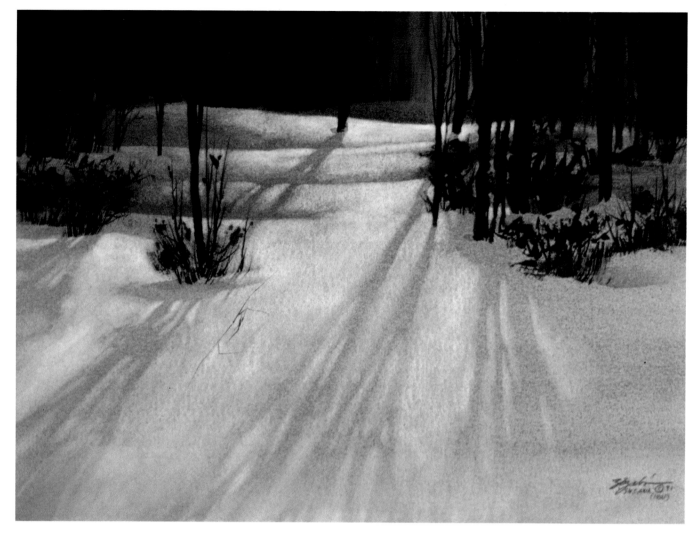

STEP FIVE

Finish:

1. Complete the lifting of the light, continuing Step Four's principles to vary the edges of the shadows and the brightness of the light. Remember to consider your distance from the light source, the shadow-casting object's distance from the surface, changes in ground elevation—in other words, obey all natural laws about light and shadow.

2. As you get farther from the light source, reduce the amount of lift.

Be sure that the light is echoed on the trees. The slower you expand the glow, the gentler the light will appear—and the more dramatic. As you get close to the foreground, you can use a bigger brush and move it in the direction of the light to leave longer, less distinct shadows.

This technique is more effective than painting shadows because a shadow does not have a texture of its own but only takes on the texture of the surface it falls on. In this case, the tooth of the paper, which is quite visible in the lifted areas, represents the sparkle on the snow.

3. When the painting is dry you can make any necessary corrections. Mix some of the original blue color to extend the shadows of the trees to the bottom of the page. Your brush strokes should go in the opposite direction, from bottom to top. Touch up any sepia areas that were lifted. You can add some positive shadows, as I did, to the small weed in the foreground.

Silver Moon
Zoltan Szabo 15" x 20"

■ PROJECT 4: PUDDLE REFLECTIONS

The most interesting things about this painting are the reflections in the puddles. They reflect the overcast sky above, but the sky itself is not visible. I chose these colors to produce the variety of warm and cool grays that dominate the color scheme:

Burnt sienna. Like French ultramarine blue, a very versatile color. The two together make a range of cool or warm grays, depending on which one is dominant.

French ultramarine blue. A rich, warm blue that tends toward purple.

Raw sienna. Adds the yellow element to this picture; when mixed with Winsor green it produces a wonderful yellow green.

Permanent rose. A transparent bright red that produces a beautiful purple when mixed with French ultramarine blue.

Winsor green. An intense, cool green that is most useful when mixed with the other colors on the palette. With French ultramarine blue, it creates a dark blue green; with raw sienna, a sap green; and with permanent rose, a subtle grayed violet.

STEP ONE

Texture Around the Puddles:

1. The first step is to paint in the texture of the ground around the puddles. At first, the puddles will be left white while the surface around them is painted with a dry brush technique. Mix a brownish gray with French ultramarine blue and burnt sienna, and apply it with a 1-inch soft brush. The brush should be only damp with color. Push the edge of the brush tip's corner against the paper in a horizontal direction to establish the edges of the puddles. Notice that perspective makes the more distant puddles appear flatter (less deep) than the foreground puddles.

2. Next, with the 2-inch slant brush, add dry brush texture to the soil between the puddles. Use the same color to dampen the brush, and push and drag the bristles against the paper in vertical strokes between the edges of the puddles. The direction of the strokes should simulate tire tread marks in the ground, but try to avoid a mechanical repetition.

In the next step, you will apply tone over this texture. So if it looks 'busy' now, it will be subdued later. Make the foreground texture toward the bottom of the picture warmer by adding more burnt sienna, and make it coarser by increasing the pressure on the brush.

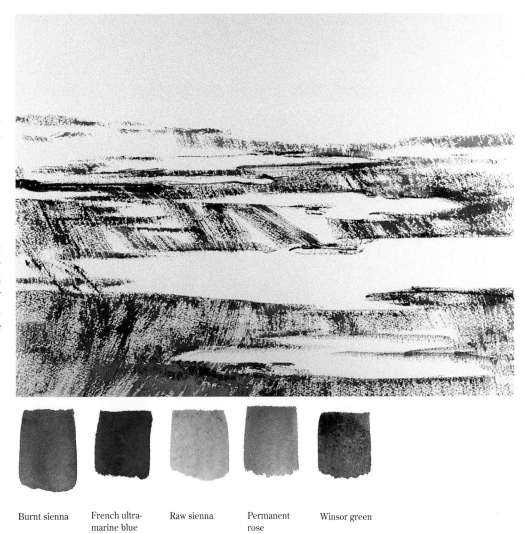

Burnt sienna French ultra- Raw sienna Permanent Winsor green
 marine blue rose

STEP TWO

The Tone Over the Texture:

1. In this step, you will paint right over the texture you made in Step One. Use a soft wide 2-inch brush to slip the color over the texture without disturbing the dry paint. Mix French ultramarine blue and burnt sienna with a bit of permanent rose to make a colorful, slightly purple gray. Apply the color with rapid strokes, starting at the top and retaining hard edges along the puddles, which are left white. Add a little raw sienna here and there for color variety and warmth, making the wash lighter toward the bottom. The color nearer the horizon should be cooler and darker.

2. Now paint in the grass in the upper right by mixing a bright olive color with raw sienna and Winsor green. Apply it with short strokes of the slant bristle brush. Add some darker accents with a mixture of burnt sienna and French ultramarine blue.

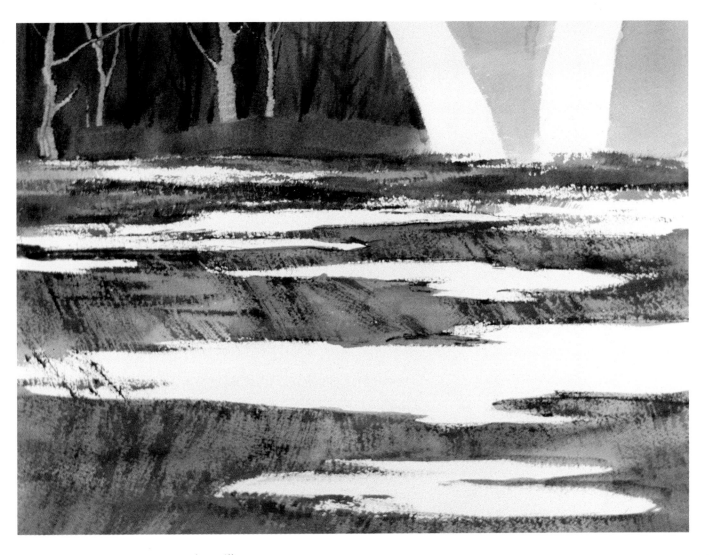

STEP THREE

The Left Background:

1. The background will be done rather quickly with an assortment of cool grays made from various combinations of French ultramarine blue and raw sienna and/or burnt sienna and permanent rose. First, wet the paper with a gray color using the 2-inch slant, leaving white paper for the sycamore tree. While the paper is still moist (tacky wet), add a deeper, richer range of grays and gray browns using vertical, irregularly spaced strokes that will suggest trees.

2. Paint the bushes along the horizon, by displacing the color there with a mixture of burnt sienna and raw sienna. Dark trees are pulled upward with brush strokes above the bushes. Lose the bottom edges into the shrubs.

3. Paint darker trees into the far background and scrape out lighter trunks with a truncated brush handle. Finally, add small trunks and more delicate branches with the rigger.

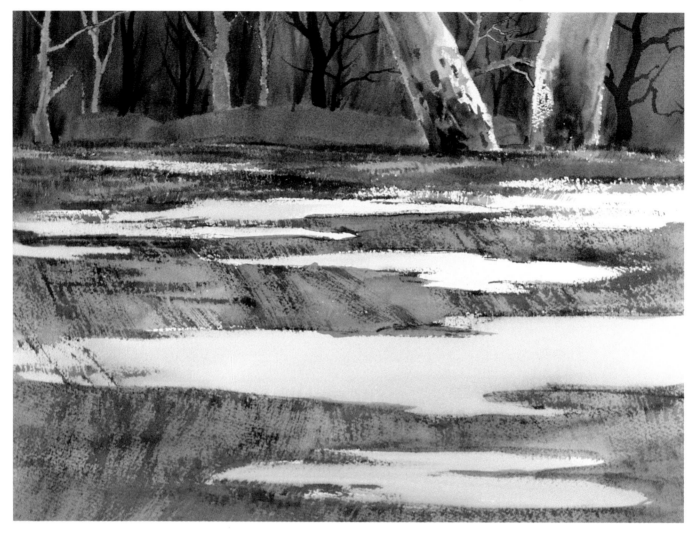

STEP FOUR

Right Background and Tree Trunks:

1. Now paint the dark background on the right following a similar procedure. Remember to make your dark really dark; it will dry lighter. Scrape the branches of the sycamore tree in the "V" between the trunks as soon as the color has lost its glisten.

2. For the tree trunks, first mix a pale, almost green value of raw sienna and French ultramarine blue. Dry brush the color on the right side of the trunks. Add darker mixes of the color toward the trunks' left and center to model their roundness. While the color is still wet, create the leopard spots of color by dropping in "jewels" of pure permanent rose and French ultramarine blue, and by dropping in darks of raw sienna and French ultramarine blue.

3. Touch up the scraped-out branches to make them less flat and more interesting. Paint in a darker silhouette of a sycamore on the far right with its typical sickle-shaped branches.

4. To give a sense of depth and perspective, add a very light tone of burnt sienna with a bit of French ultramarine blue to the puddles. The tone should be a bit stronger in the foreground puddles and a bit lighter in the ones on the horizon. The puddles nearest the sycamore can be almost white, since that area is where the center of interest is located. Stroke the color on with rapid strokes; don't scrub. Overlap the edges just a bit.

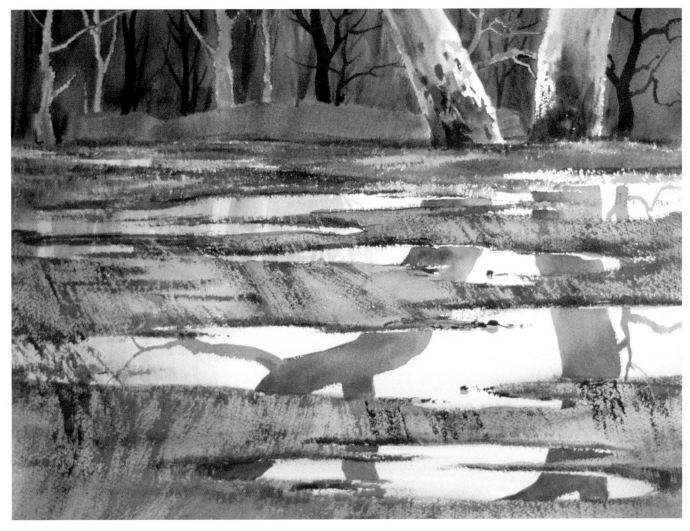

STEP FIVE

Reflections in the Puddle:

1. Wait until the tone on the puddles is dry before painting the reflections. They need sharp edges. The color of the reflections shows the color of the water—in this case, mud. It also shows less distinct texture. Mix permanent rose and a little French ultramarine blue, and paint in the reflection of the tree trunks. Leave a bit of white at the very top of the reflection by the grass.

2. The value of the reflection cannot be darker than the darkest value of the water's local color, although the color of the reflection gets darker as it gets closer to the bottom of the paper. This is because the closer you are to a puddle, the deeper down into the puddle you can see. Carefully check the angles and curves of the tree so you get a true mirror image of it.

The puddles reflect the upper branches of the sycamore, unseen in the real tree above. Make sure both sides of the reflection are not the same value, which would look unnatural and boring.

3. Add some vertical strokes of grayed color to the puddles in the upper left to indicate the woods beyond.

Add some darker, broken color along the edges of the puddles and reinforce the texture of the soil with a rich mixture of burnt sienna and French ultramarine blue.

Reflecting Giants
Zoltan Szabo 15" x 20"

■ PROJECT 5: SPIDER WEB

I found this fascinating example of nature's structural engineering behind an abandoned warehouse. The visual appeal of this painting is based on the contrast of the spider's web against the dark background. The web itself was scratched out with a utility blade after the painting had dried. I determined which colors to use by avoiding any pigments that could deeply stain the paper, which would make it difficult to scratch out the web. The following were my choices:

French ultramarine blue and **burnt sienna** will be mixed to create a neutral gray dark enough for the background.

Antwerp blue. A cool, light-staining blue that will make good darks useful for modeling the background.

New gamboge. A pure, somewhat warm yellow that makes a bright, sunny green when mixed with Antwerp blue or a dull, shadowy green when mixed with French ultramarine blue. It stains.

Cerulean blue. An opaque, settling blue that will be used for the milky softness of the foreground. It does not make good darks but will add variety to the greens.

Permanent rose. This is a primary red that does not stain. It has the wonderful quality of being able to sparkle through other colors.

STEP ONE

Background and Foreground Shapes:

1. First wet the paper with a 3-inch soft bristle brush, wiping up any excess water from the edges. This whole step will be done while the paper remains wet, so work quickly and decisively. Mix a rich gray with burnt sienna and French ultramarine blue, and wash it on the paper with big, bold strokes of the 3-inch slant brush. Don't blend it evenly. Next, mix a darker gray of Antwerp blue and permanent rose, and brush it on to make a variegated, visually interesting gray.

2. Wash in some new gamboge into the foreground. Mix a bright green with cerulean blue and new gamboge, and stroke it into the yellow color for the areas of foliage in shadow.

3. Now suggest some trees in the background. Mix Antwerp blue and permanent rose and, using strong, angled strokes, add it to the gray of the still-wet background. Mix a deep, rich dark with Antwerp blue, French ultramarine blue, burnt sienna and permanent rose, and boldly paint it into the background to create tree shapes. Use the 3-inch slant brush; wet the short bristles with clear water and charge the long bristles with color. By switching which corner of the brush strokes the paper back and forth, you can get softly graded results. Because colors are still wet, all the edges will remain soft.

French ultra-marine blue Burnt Sienna Antwerp blue New gamboge Cerulean blue Permanent rose

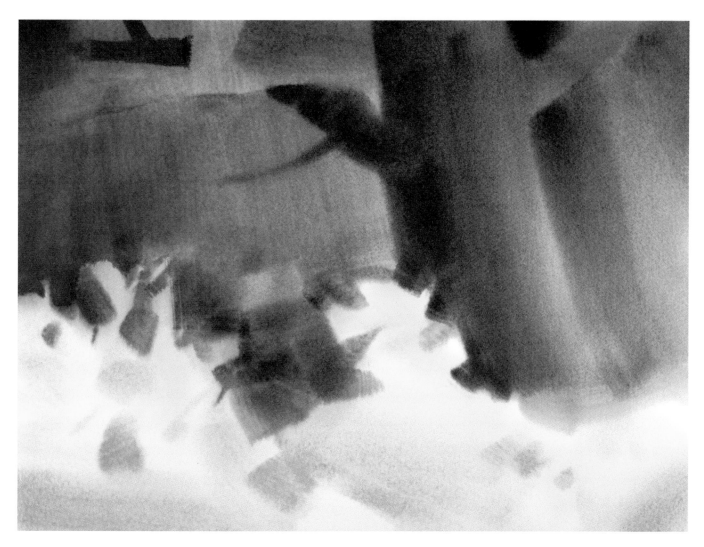

STEP TWO

Dark Accents:

1. After the background is dry, mix Antwerp blue and permanent rose, and add a layer of color onto the existing colors. Again, dip only the corner of the slant brush's long bristles into the color, so the strokes are graduated dark to light. The colors will blend into the previous wash.

Add dark accents in the upper left corner to keep it interesting. These shapes can be almost abstract; mine suggest a tree limb.

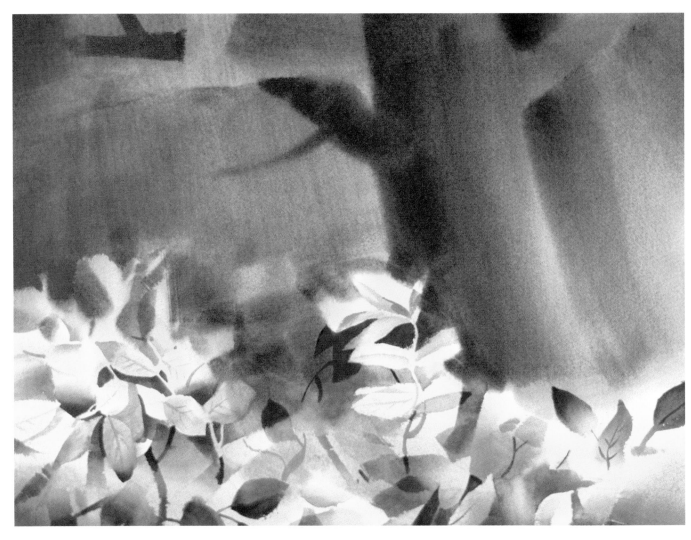

STEP THREE

Leaf Shapes:

1. Now that the paper is dry, add sharp edges in the foliage by painting leaflike shapes with cerulean blue and new gamboge. Also make sharp edges with a transparent green mixed from new gamboge and Antwerp blue.

The foreground leaves should be in sharper focus to create a sense of depth and to harmonize with the delicate web. The positive shapes of the leaves will grow with the establishment of the negative forms around them.

2. Add French ultramarine blue and Antwerp blue to new gamboge for rich, darker greens. Apply with the small slant brush, adding some burnt sienna and new gamboge to get olive greens and yellow greens. Build up the foliage, alternating between painting the positive shapes of the leaves and negative shapes of the background.

3. Make lost-and-found edges on parts of the paper that are dry. Do this by combining wet-on-dry and wet-in-wet techniques, softening edges with the thirsty slant brush. Allow the shapes to emerge gradually. Add sensitively felt accents.

4. Use cerulean blue and French ultramarine blue to make a cool, midvalue for the central leaves, using the slant brush to make fan-shaped strokes.

Notice how many of the leaves are half in light and half in dark.

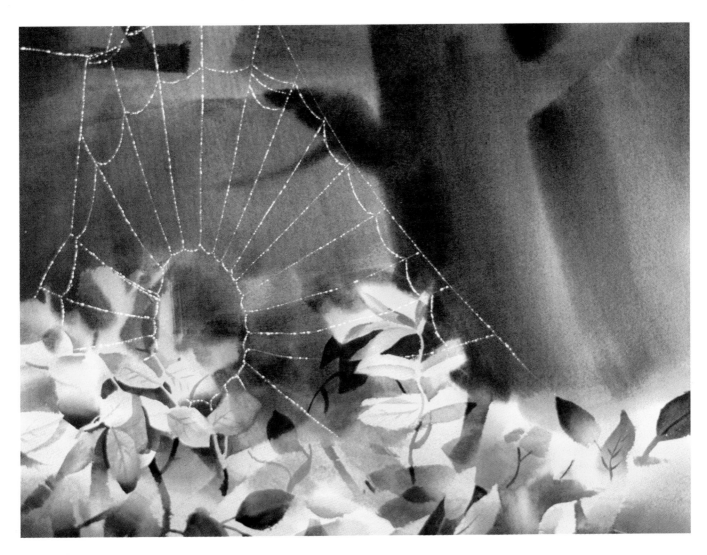

STEP FOUR

Scrape Out the Web:

1. When the background is bone dry, scrape in the web using a razor blade or a fine-tipped steel blade in a utility knife. First scratch out the long, sweeping lines for the supporting strands of the web. These should be fast single strokes. None of the lines should be parallel to the edges of the paper. You may need to go back and carefully scratch out the lines so they are whiter. The paper will not "engrave" smoothly but will make irregular, blobby lines suggesting dewdrops on the web.

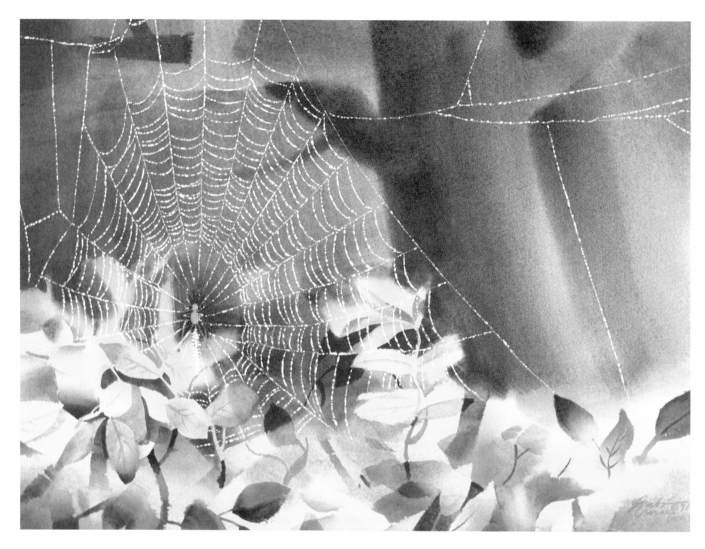

Mr. Cobb
Zoltan Szabo 15" x 20"

STEP FIVE

Crossbars and Finish:

1. After scratching in the radial strands of the web, scratch in the crossbars. This is a somewhat tedious process that will take some time (but it will be easier than the spider's job). Remember to vary the spacing slightly, and remember to take into account the pull of gravity—all the crossbars will sag slightly toward the bottom.

2. Lift out the pigment in the very center of the web with a stiff bristle brush. Scratch in the legs of the spider with the knife, just as you did with the web. Paint in the body of the spider right over the lifted area in the web's center so the spider takes on the form.

■ PROJECT 6: SNOWY CREEK

The goal here is to recreate the look of the beautiful late afternoon light on this snow-heavy creek bed. The key is to show the warmth of the light on the snow and the bluish gray coolness of the shadows. To accomplish this I chose the following palette:

New gamboge and **alizarin crimson.** Both staining colors, for the warm sunlight.

Burnt sienna. A good color for background darks.

Antwerp blue. A transparent blue that will go very dark.

French ultramarine blue. A more reflecting, potent blue for the dark water.

Sepia. A dark staining color for accents and dark, warm details.

STEP ONE

Warm Lights, Cool Shadows:

1. Wet your paper, using a large, soft, clean brush. Mix an orangey wash of new gamboge and alizarin crimson. Be sure to put enough color onto the paper, because both of these colors will dry back (become lighter) considerably.

2. With the large, soft brush, start at the top of the page so that the orange wash shows as light behind the trees that will be painted later. Vary the color slightly as you go. Cover the whole page with this tint. Add some vertical strokes at the top of the paper to deepen the color.

3. Mix French ultramarine blue and alizarin crimson with a little Antwerp blue. Sweep on some cast shadows from trees outside of the picture plane. Start to define the rim on the creek bed with this cool color. To get soft edges, define areas of shadow while the paper is still wet. You can use a smaller and a larger brush—smaller for the narrow bands of shadow, larger for the broad bands. Indicate the areas of drifted snow. After the first shadows are dry, you can glaze in some deeper values.

New gamboge Alizarin crimson Burnt sienna Antwerp blue French ultramarine blue Sepia

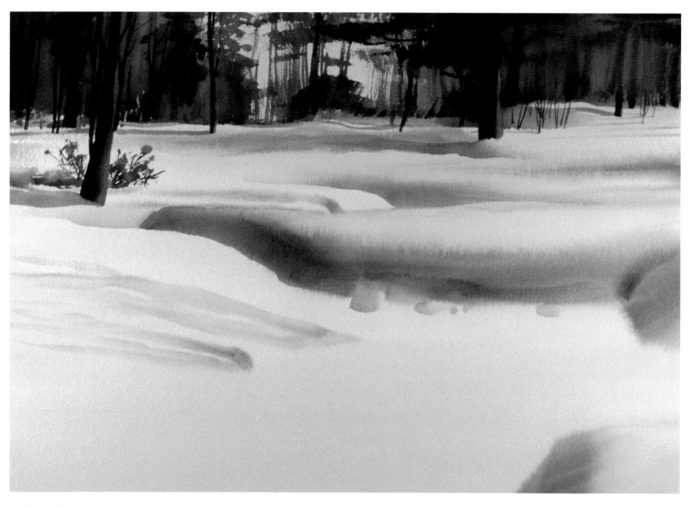

STEP TWO

Background and Middle Ground:

1. Paint the darks in the background with a slant brush and a very warm, rich color mixed from burnt sienna and French ultramarine blue. The slant brush is a wonderful tool for creating treelike textures in an economical way. Add warm, dark gray (burnt sienna, French ultramarine blue, alizarin crimson) to deepen the value on the left side, still painting the trees en masse. Use a cooler mixture by increasing the percentage of French ultramarine blue for the right side. Leave the occasional miss of the brush to show the light com-

ing through.

2. Mix some Antwerp blue, alizarin crimson and burnt sienna. With a smaller brush, give the forms a pinelike rhythm by pulling the dry brush upward. Mix a darker color from Antwerp blue, French ultramarine blue and sepia, and make some darker horizontal strokes indicating branches, using the slant brush again. Keep most of these horizontal strokes on the right side of the picture. While the paper is still damp, touch up some of the edges with a warm dark of alizarin crimson and Antwerp blue. Glazing on top of damp paper results in a darker color with fuzzier edges that

won't compete with the focal areas. Try to get as much variety as you can in shapes, subtle value changes, and color temperature within the overall warm frame.

3. For the middle ground, clarify and elaborate on the shadows of the snow banks and the cast shadows of the trees with a mixture of French ultramarine blue and alizarin crimson. Sharpen the forward side of the embankments and lose the far edge by laying down a brush stroke and then immediately losing the top (far) edge. Use a quick stroke with a clean, thirsty (barely damp) brush.

Now for tree shadows: Remember to be consistent

with your light. In this case the light is coming from the right so the shadows are going left. Sharp images and objects close to the surface cast sharp shadows.

4. Mix burnt sienna, alizarin crimson and new gamboge. With this bright reddish color, bring the shape of the tree trunk on the left down into the snow area. Add sepia to the mixture and glaze it over the trunk; then lift some of the color on the light side of the trunk. Add some foliage around the trunk's base and the shadow for consistency. With a rigger, add some calligraphic darks.

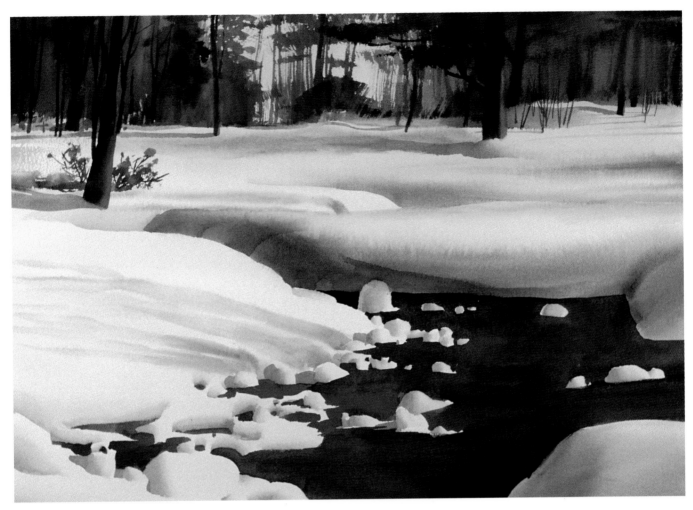

STEP THREE

Water and Snowy Rocks:

1. The water calls for a carefully planned and executed liquid wash that will leave out negative shapes for snow-covered rocks. You will advance down from the distance (cool) where you see more sky reflection, to the rocky base in the front (warm). Use a mixture of burnt sienna, alizarin crimson and French ultramarine blue, which you can adjust cooler or warmer.

With a medium flat, soft brush (3/4-inch), using the corner often, paint fairly dark. (Reflections of the snow will be lifted out later.) Leave the areas for the snowy mounds of rocks in the water and on the shore-line. The top edges of the rock shapes are rounded off; the bottoms can be flatter.

2. As you bring the color forward, keep moving so the advancing edge of the wash doesn't get a chance to dry. Expand the color gradually enough that you have time to check the edges and get a varied but repetitive pattern of rocks. I have made it slightly warmer on the left side to show the sunlight and the shallowness of the water. After my original color was dry, I went back and added some Antwerp blue to cool and darken the color of the water. Check the edge of the creek bank for monotony—if it is too straight, cut into it with color. Be sure to let this step dry completely.

3. When the area around the creek is dry, begin modeling the snow with lost-and-found edges. Build this part of the painting one stroke at a time, being sensitive to the growing details. You can't predetermine all the shapes.

4. For the shadows, use a variable mixture of Antwerp blue, alizarin crimson and French ultramarine blue. Mix the color darker than you want it because when you soften the lost edge you will pick up some of the color and lose value. Use the following technique to shade the shadow side of each little snow hump: Make your brush stroke. Have the clean, thirsty brush ready in your other hand. Bring a damp brush stroke across the edge you want to lose, going into the paint from the dry side. If the brush is too wet, it will create a back-wash and wash the color back in; so blot the brush before softening the edge and whenever you touch a thirsty brush into paint. Blot the brush immediately after also, to take off the color. This is where some of your original color will be soaked up. Some of the color will also spread out into the moistened space, so be sure to start a little darker. If you accidentally wet a dry color, blot it immediately. This central area will be your center of interest, so take some time and care to complete it.

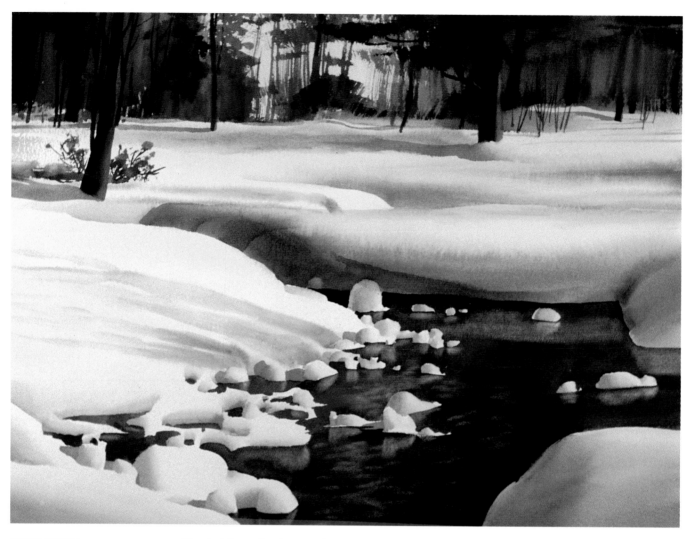

STEP FOUR

Reflections in the Water:

1. To achieve the bright white snow's reflection in the dark water, we will lift some of the color. The water's color is staining enough that quite a bit will still be left after lifting. Check your painting and your reference to see where the reflections would occur logically.

For areas that are farther from the reflecting source, simply wet the surface with a soft brush and blot. For brighter areas (reflections of rocks on the surface), use a firmer bristle brush and scrub harder to lift more.

The brighter the image, the brighter the reflection needs to be.

Make sure you are consistent with all the bright spots, and match up all the angles. The reflections in the creek shouldn't be too sharp because the water is moving.

2. Pick out a few zig-zag wave shapes. These prevent flat areas in the water from looking too dull. Hold the wet brush horizontally and rub lightly. Blot with a tissue after you loosen the paint. You don't want these shapes to compete with the reflections.

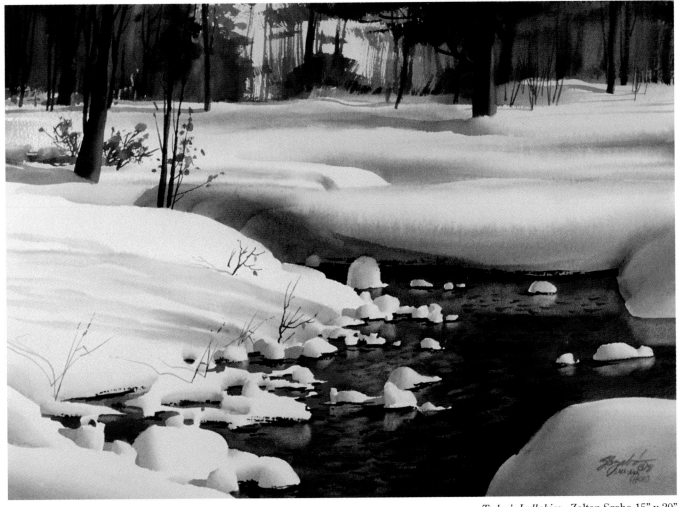

Today's Lullabies, Zoltan Szabo 15" x 20"

STEP FIVE

Finishing Touches:

1. For the weeds, mix burnt sienna and alizarin crimson to a rich liquid consistency, and mix some sepia and Antwerp blue for accents. Find a strategic location to which you want your viewer to be drawn. Use the tip of your palette knife to pull out branch shapes. Add the sepia mixture for accents on the bottom. Point the branches in a direction that is to the painting's advantage. You can also use a rigger to put in some weeds next to the rocks.

When these weeds are in the warm sun, always use a rich combination of warm color. The weeds in shadow can stay cooler. Add some new gamboge to your burnt sienna mixture, and dab some leafy-looking shapes to the branches. Add some young trees in the left middle ground. The sepia mixture helps them disappear behind the snow bank.

2. For consistency, show the cast shadows for these new sunlit shapes, except for the ones in the shadows. These additions increase the clutter of the area, thereby reducing the competition between this section and the focal area of the creek.

3. For darks in water, use sepia as your base; add burnt sienna for warm darks and Antwerp blue for cool darks. First, paint dark shapes directly under the rocks to show what is holding up the white shapes. Some of the larger shapes are broken up into smaller shapes. Next, use the side of your rigger to show the uneven texture of the far bank's edge. Then use the cool darks for shadows where the snow meets the water in the shade (center). Use the side of the rigger here in a textured manner, too. You can redesign the shoreline if you want at this time.

4. Use diluted sepia by itself, and give the water a feeling of waves coming toward the foreground. These should match up with the lifted waves. Don't overdo it. These decorative touches need to get somewhat lost so they blend into the medium-dark value.

5. I made some minor adjustments in the background with Antwerp blue and sepia to give more dark value and make the trees look more like pine. I did this with some strokes from the bristle brush, as well as with the rigger for some of the branches.

■ PROJECT 7: WATERFALL

This painting was inspired by a waterfall in Yosemite National Park. In this project, you will use value and color to create depth by placing warm, darker colors in the foreground, and cool, lighter colors in the background. You will also work with glazes, starting with wet paper and then working on dry paper. Don't be a slave to your reference photo. I deviated quite a bit from the photo I was working from and chose a horizontal format for better composition and to enhance depth.

The colors were determined more by my vivid memories of the subject than by the ones in the photo. I chose the following colors:

Cobalt blue. A warm, primary blue that is pure but does not go dark.

Permanent rose. A cool, transparent primary red that is clear and intense, but it also does not go dark; mixed with cobalt blue, it makes what I call a "pretty mauve."

Antwerp blue. A dark, transparent blue that can make dark greens.

New gamboge. A yellow to mix with the blues for the rich greens. Use new gamboge cautiously; keep it out of the background and middle ground.

Burnt sienna. For making your darks; mixed with Antwerp blue, it will make a very useful deep green.

French ultramarine blue. For the darks in the foliage.

STEP ONE

The Background:

1. First raise the top of the board about an inch. Apply clean water on the top two-thirds of the paper with a wide, soft brush until the surface is wet but not saturated. Using the soft 2-inch brush, apply a mixture of a rich but quiet mauvelike gray made of cobalt blue, a bit of permanent rose, and just a touch of new gamboge to neutralize it. Let the pull of gravity help the wash flow downward.

2. Leave white paper for the bright central area. Stroke downward, adding some Antwerp blue. Never use one color; add related colors to make it interesting. Since the pure white of the paper is too strong for the composition, make a very pale blue wash and go over the central white area to suggest mist. Use downward strokes to indicate the movement of the water.

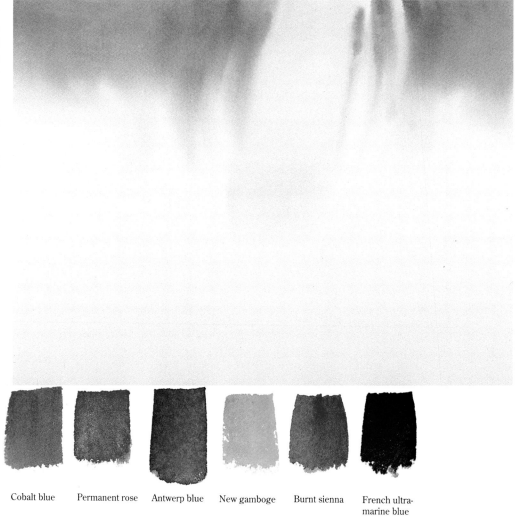

Cobalt blue Permanent rose Antwerp blue New gamboge Burnt sienna French ultra-marine blue

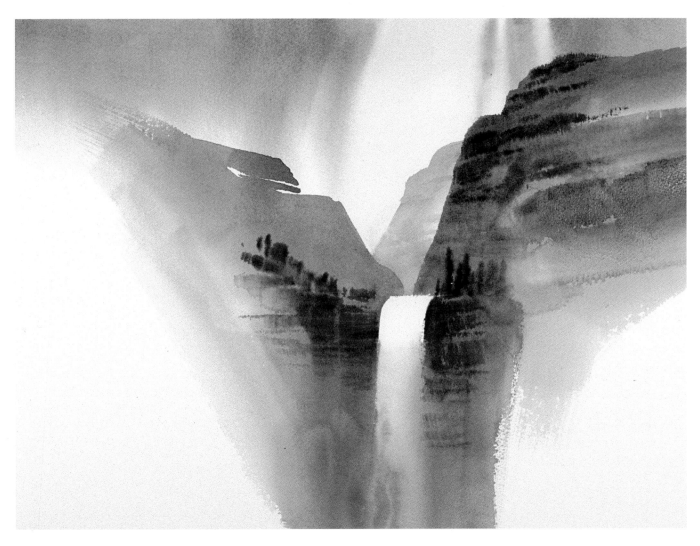

STEP TWO

The Middle Ground:

1. When the paper is dry, mix a rich color from all the colors except burnt sienna, and paint the middle ground. Start with the 2-inch soft brush. Shift to the slant bristle brush to cut in a hard edge of the foreground mountain, and lose the other side with soft strokes. Keep the shapes bold but gentle. Use more Antwerp blue toward the falls in the center, matching the color on both sides of the falls. While the falls are still wet, paint over the lower part with a dilute mixture to give tone. Add some wiggly medium tones as the falls break up where the water descends.

2. Make a deeper color with cobalt blue, burnt sienna, Antwerp blue and permanent rose, and paint a new elevation on the right to get a layered effect in the mountains. Texture the interior of the mountain with complementary shapes and textures, but go easy. Mix Antwerp blue and permanent rose with burnt sienna, and decorate the dark ledge to the right of the falls with tree shapes made by touching vertically with the corner of the slant bristle brush.

3. While everything is still damp, add more foliage on the mountains by using the slant brush with a green mixed from cobalt blue, new gamboge, Antwerp blue and burnt sienna. Then use varying amounts of Antwerp blue to make the really dark touches.

Adjust the mountain's edge by the top of the waterfall and add texture to the far mountain slope on the right.

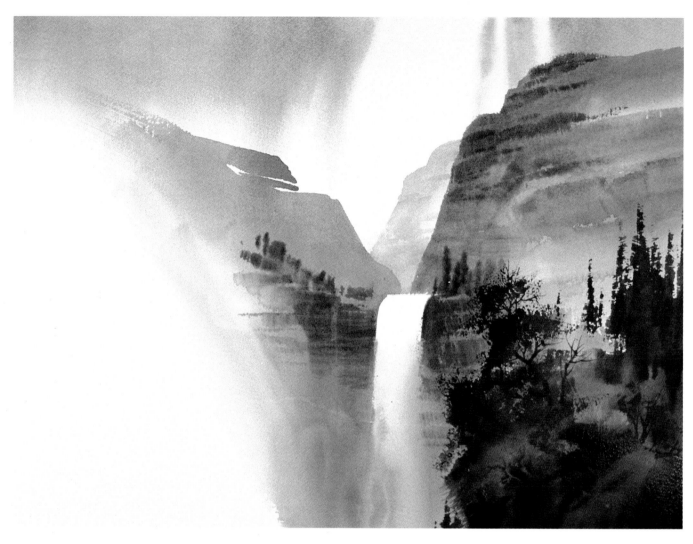

STEP THREE

Foreground:

1. The dark and light greens form the two main values of the foreground. But first, mix new gamboge and permanent rose to make an orange; soften and dull it with a touch of cobalt blue. Use the side of the brush to get a lacy effect of colorful flowers or foliage in the center part of the right foreground. Vary the color with Antwerp blue to make a darker green. Shove the bristle end of the brush into the paper to get an exciting, lacy edge. You are not painting exact tree shapes; you are suggesting trees, allowing your brush to discover the shapes as you paint.

2. Establish the area, adding value and color to avoid isolated elements anywhere that could be distracting. Use the 2-inch slant bristle and a dark green mixed from burnt sienna and Antwerp blue, allowing the fuzzy edge to create little pine tree shapes. To paint the trees on the right, start with units of dark pine foliage. Make Antwerp blue the dominant color for cool, dark greens, and mix it with some burnt sienna. Add dark, lacy, dry brush strokes to the trees to contrast with the middle ground values.

I added some broad dark green strokes in the lower right at this point, after I had looked everything over.

3. Next, paint a few branches supporting the foliage you just painted for scale and for "eye breaks." Pick out branches in the dark values with a pointed brush. Paint some dark negative shapes around lighter branch shapes to act as a foil to the strong contrast of the falls. This produces a counterchange of dark against light and light against dark—a very pleasing art element.

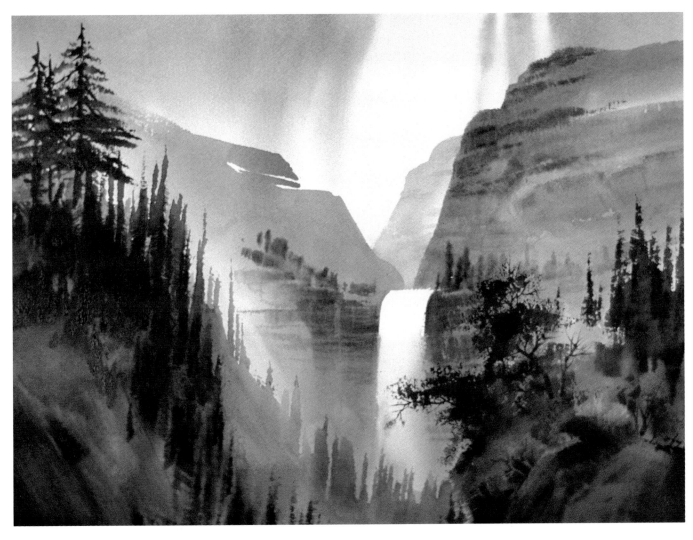

STEP FOUR

Left Foreground:

1. Finish the left side of the composition by working quickly with a 3-inch slant bristle brush. Define the general shape with a green made from the two blues and burnt sienna. Establish scale and value. Hold the brush so the long bristles that hold the color are toward you, the short end facing upward to make tapered pine tree shapes right across the waterfall.

Point the trees into the dry background. Now use more paint on the damp surface, varying the color with new gamboge.

You don't want both sides of the composition to look even. Use sideways strokes to make loose, free shapes. Make pine tree shapes by "fanning" pointed wedge shapes with the bristle brush. Avoid making any mechanical, repetitive, parallel shapes.

2. With a mixture of burnt sienna and new gamboge and a 3-inch slant bristle brush, paint some bold, varied shapes of color. As they dry, go over them with more and darker colors to get texture, using the fuzz of the brush. Use the rigger to add dark branches, distant trunks, and other details of texture on the trees.

3. The composition needed something to relate the falls to the cliffs. Add the extension of foliage in front of the waterfall.

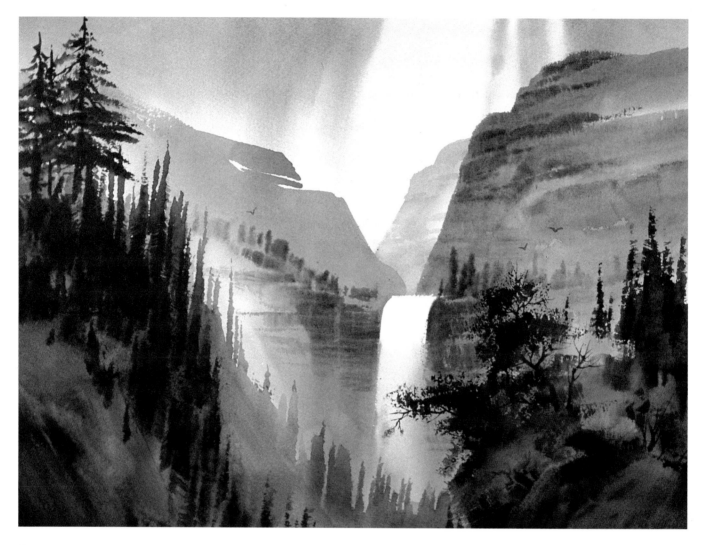

Mountain Ribbon
Zoltan Szabo 15" x 20"

STEP FIVE

Finishing Touches:

1. Add some finishing touches. Extend the line of middle ground trees on the left center with a warm gray. Use the same gray to elaborate gently on some of the other distant foliage. Add a bird or two in the distance. Check your painting for any areas that need clarification—but don't overdo it.

■ PROJECT 8: STILL WATER

Calm water has always fascinated watercolor artists. It reflects the sky and shoreline almost like a mirror, so keep the following ideas in mind. First, reflections appear directly below the reflected object. Second, the colors of the reflection of dark images are usually lighter, because reflections will be dominated by the local color of the water.

My color choice was determined by the need to make warm colors dominant, offset by rich, cool darks. My colors were:

New gamboge. A rich staining color that will be the basis for the warm glow of the sun. New gamboge has a tendency to exaggerate its strength while wet, so you have to overdo it a bit so it looks right after drying.

Alizarin crimson. Combined with new gamboge, this cool, deep red makes a bright orange that, used in the sky, will effectively communicate a low sun condition to the viewer.

French ultramarine blue. A color that will also help to paint the sky with the sun near the horizon.

The above colors don't make good darks, so we will also need:

Winsor blue. An intense, dark, rich staining blue to make the darks you need; however, a mixture of Winsor blue and alizarin crimson will be too warm because of the strength of alizarin crimson.

Sepia. A dark that will allow the mixture of Winsor blue and alizarin crimson to go "cool."

Burnt sienna. For neutralized, warm darks and for shadow details.

STEP ONE
Sky and Background Trees:

1. Wet the top three-fourths of the paper. You want to wet the paper lower than you will go with the color, allowing room for the mist on top of the water.

2. With a mixture of new gamboge and alizarin crimson, start at the top with a dilute mixture and wash down, adding color where the strongest color will be. Make this color a darker value than you think necessary, because it will dry surprisingly lighter. Make the color particularly strong where the sun will be.

3. Now mix a somewhat blue and fairly dilute mixture of French ultramarine blue and alizarin crimson, and begin to lay in a wash from the top down. Use a soft, wide brush and stroke the paper horizontally without stopping to make a graded wash. Blend with the still-wet yellow about one-third of the way down.

4. Using the 2-inch slant brush, start developing some colors of evergreen with a cooler, more concentrated mixture of French ultramarine blue and alizarin crimson. At the same time, roughly establish the water line by starting the vertical strokes there. Use horizontal ones around the center where the sun's glow will be. As the color moves away from the light, add more French ultramarine blue to cool it.

5. The lower edge of the foliage has to be lost, so go over it lightly, using quick, sweeping strokes with a clean, wet, 1-inch bristle brush.

6. Now paint the reflections. Wet the paper underneath the horizon line, and use lots of new gamboge and alizarin crimson to make a darker value of the colors used for the sky. Use a mixture of more burnt sienna and less alizarin crimson for the darker values of the warm colors in the reflection. Make sure the reflections are consistently related to the shapes directly above.

Remember, the reflections will be lighter in color than the dark image because of the local color of the water, which dictates the value of the reflection.

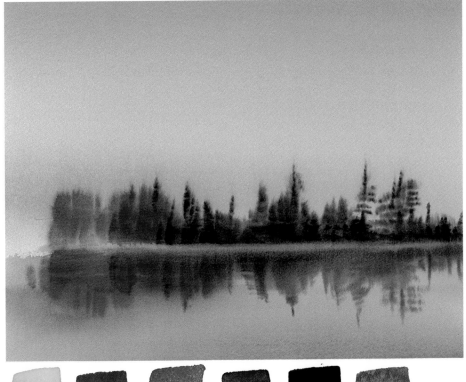

New gamboge

Alizarin crimson

French ultramarine blue

Winsor blue

Sepia

Burnt sienna

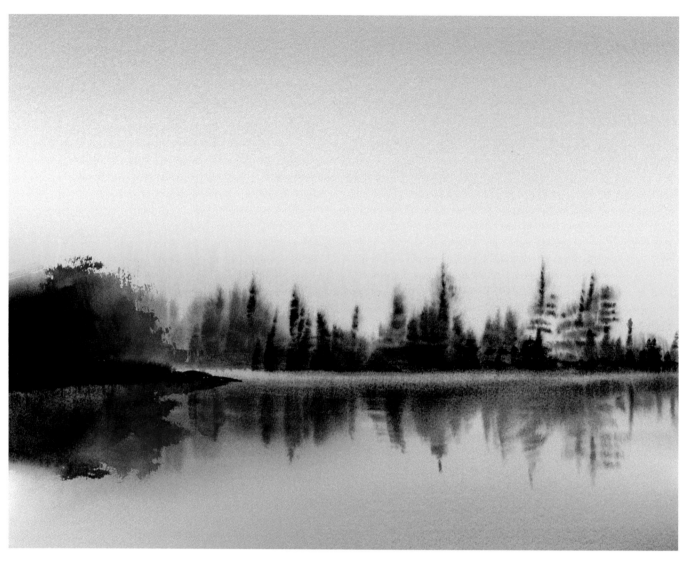

STEP TWO

Backlit Trees:

1. Now paint the glowing backlit trees in front of the sun. With the 1 1/2-inch slant brush, using a mixture of alizarin crimson, new gamboge, and a little burnt sienna, paint the shape of the trees dark enough to really glow. For the outside of the glowing area, use burnt sienna and French ultramarine blue, and lose the edges with the short end of the brush. Add the reflection at the same time, the reflection color being a little lighter.

2. For the darks coming in from the left, use French ultramarine blue with a little alizarin crimson and new gamboge. Wash the darks into the other drying colors.

3. While it's still damp, give some depth to the lower edge of the dark reflection on the left side of the painting. Add some shapes for rocks. The island should be well established as an important location.

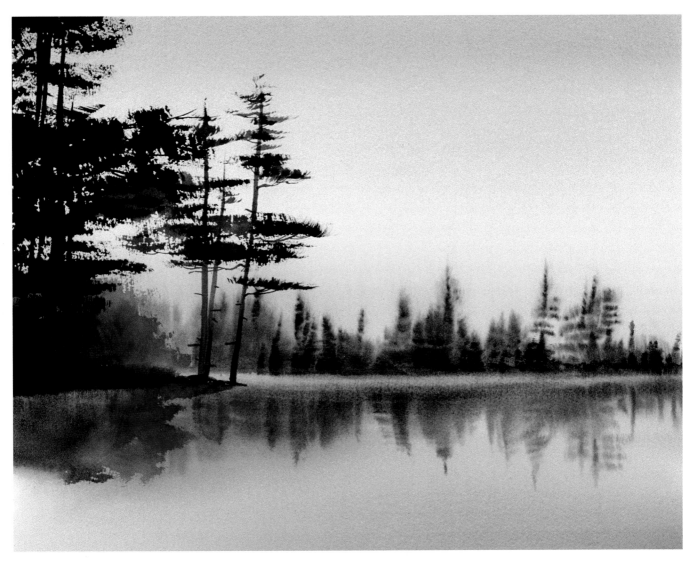

STEP THREE

Tall Trees:

1. The trees right around the light source will be quite dark in relation to the bright light behind them. Wet the large slant brush with rich sepia, warmed with burnt sienna and alizarin crimson, and place the dark shapes of foliage right on the sky wash. Model the shapes using your large brush. Toward the top of the paper, use a cooler sepia, this time mixed with Winsor blue. Bring these tree shapes all the way up to the top of the paper. The cool tones should come in around the warm shapes.

2. With a smaller brush, clarify the large brush work where needed (such as attaching the branches to the mass of foliage). A rigger can help pull out these little shapes. They also have to get warmer as they near the sunny area.

3. For the trunks right in front of the sun, use alizarin crimson, new gamboge and burnt sienna. Start warm and then get cooler near the base. Pine branches go out from the trunk and then curve up toward the foliage. Add a few broken limbs typical of pines, but work carefully as you add these foliage clusters to the pristine background.

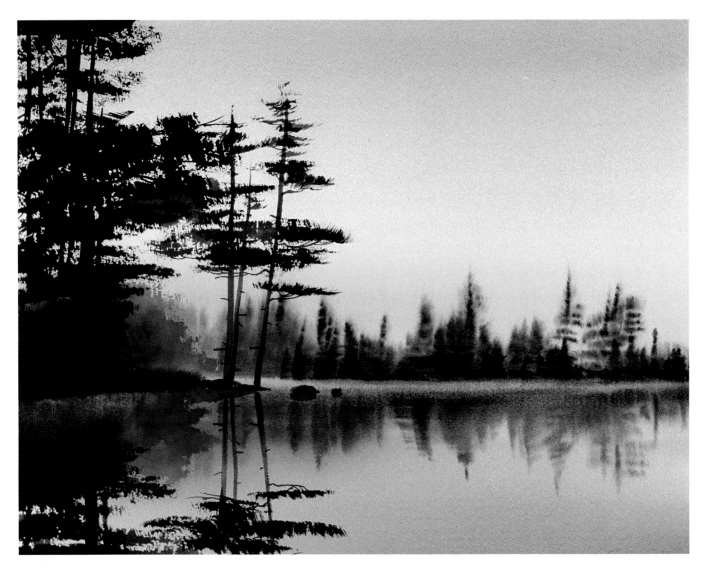

STEP FOUR
Reflections of Tall Trees:

1. In painting the reflections of the tall trees, remember to check carefully that the reflection follows consistently the lines of the trees. The angles, of course, must be reflected in the opposite directions. Also make sure you mirror what would appear from where the reflection is, not from where you are.

2. These dark reflections are slightly lighter than the subject. I added a little rock in the center so the dark area doesn't line up exactly with the bright sun area. Your order, from top to bottom, is cool darks first, then warm darks, then the reflection right below.

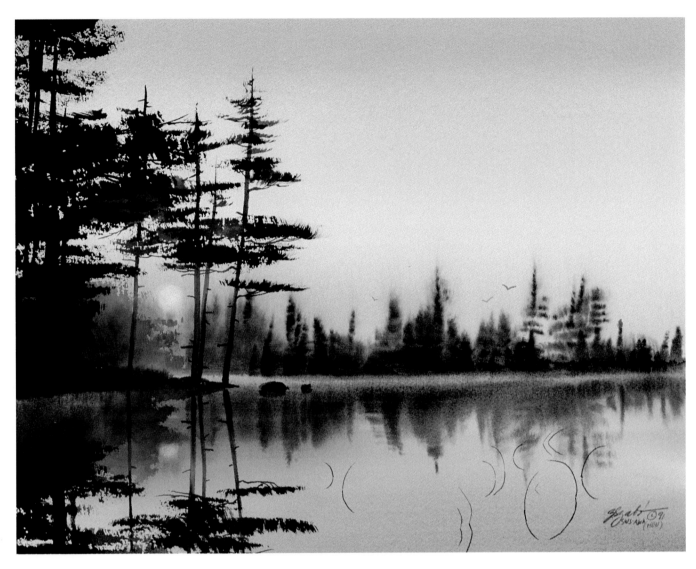

STEP FIVE

Lifting out the Sun:

1. In this step you will lift out the small circular area of the sun. With a small, firm, dampened bristle brush, make a circular motion in one spot in the warmest part of the sky. Blot the loose pigment right away with a tissue. It will not be pure white because we purposely used staining colors in the early washes. You want to make the edges of the circle look soft.

2. Add the reflection of the circle, but only lift out part of the circle, because it is partially covered by branches. There must be less contrast in the reflection, so that there is only one center of interest. Mine wasn't yellow enough, so I added a small amount of new gamboge.

3. Add some more bushes to the left of the sun, making them yellowish red near the sun and darker toward the base. Add the reflections where they belong.

Add a few warm weeds in the water at right to balance all the activity at left. These are hairline weeds painted with the rigger. Each has its reflection in the water.

Add a few birds to the left. Make sure they don't line up evenly, so they can't be easily counted.

The Show-off
Zoltan Szabo 15" x 20"

■ PROJECT 9: DISTANT MIST

The subject of this painting is a subtle one. I painted it from a photograph of an island engulfed in fog. The fog was so thick that the photographs showed only the dark mass of the house on the island.

These are the colors you will use:

Sepia. A neutral, staining color that will get weaker when diluted but will not move or come off when dry. Be gentle with it.

Cerulean blue. A naturally soft, pastel color. It is opaque and will be used to cover some of the sepia in the background.

French ultramarine blue. A warm, somewhat violet color that will be used to make the sepia less harsh.

Raw sienna. A mellow, neutralized yellow that makes a good green when mixed with Antwerp blue.

Antwerp blue. A blue with a little green in it.

Burnt sienna. A real work horse; a dull but pure orange. It is neutral and transparent.

STEP ONE
Paint the Silhouette:

1. On a dry paper, paint the silhouette shape of the cabin using the large, wide, soft brush and a light wash of sepia and French ultramarine blue. The color should be rather light; I suggest you test it on scrap before painting. Work fast so it is a unified whole. Lose the bottom edge of the shape so it is soft. While the shape is still damp, make the dark shadow side of the building. Let the paper dry.

Sepia Cerulean blue French ultramarine blue Raw sienna Antwerp blue Burnt sienna

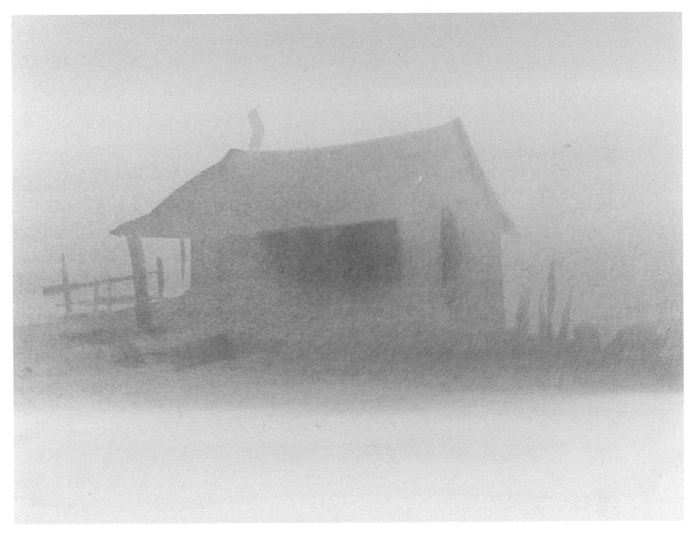

STEP TWO

Create a Mist:

1. Wet the whole paper with the wide, soft brush. Use clean water and back-and-forth horizontal strokes. Go right over the house. Since you used staining colors and are *not* scrubbing the color with the brush, the color should not move. Now wash over the entire image with cerulean blue and raw sienna.

2. Add a wash of raw sienna and burnt sienna, and use the same stroking motion on top of the previous wash to warm it up a little. Add more cerulean blue to the mixture and continue applying the color. It may take two or three continuous applications until there is enough color to make the image misty.

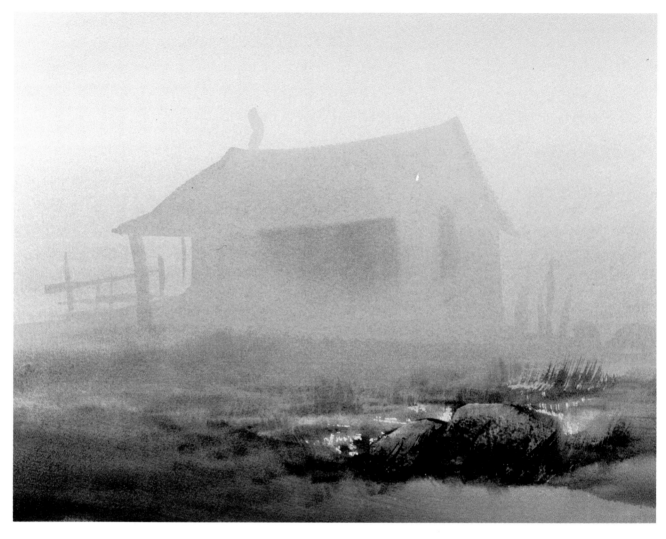

STEP THREE

Grass Textures:

1. Add some raw sienna to the mixture to make it more yellow. Use the 2-inch slant brush and blend the mixture into the existing colors on the bottom to make a warmer foreground. Make a grayish green; touch the paper with the bristle tips and flick the brush upward to create the texture of grass. Add Antwerp blue to make a darker green. Neutralize this with burnt sienna and Antwerp blue to make a dark, warm foreground.

2. Use a dark, rich tone of burnt sienna, raw sienna and French ultramarine blue to make a foreground rock. Add Antwerp blue and French ultramarine blue for the shadow at the rock's bottom. While it is still damp, texture the rock with the heel of the palette knife. Make the top surfaces lighter, tapering to a dark toward the bottom.

3. Mix cerulean blue and raw sienna to make a grass-green, and add a little Antwerp blue and raw sienna for foreground grass. Detail and texture the foreground with a 2-inch slant brush to make clusters of grass.

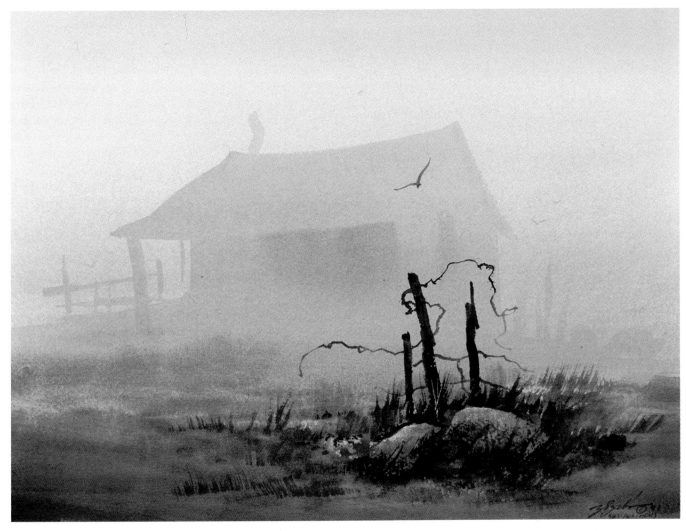

STEP FOUR

Finish:

1. When the previous step is dry, lay down a pale coat of cerulean blue in the foreground to color any white speckles. With a mixture of cerulean blue and Antwerp blue, flick your 1-inch soft, flat brush with your fingers to make splatter on this foreground area. This will add some nice touches of blue sparkle.

2. Mix Antwerp blue and burnt sienna to make a dark for the dark, weedlike clusters behind the rock. (See Step Five for details.) For the extension beyond, use French ultramarine blue and raw sienna.

3. Now add sepia and Antwerp blue to the base color to make a fence post. Add colors to enrich it. Paint behind the grass at the base, then use the tip of the brush handle to scrape out light weeds in front of the post. Stay playful; don't try to pre-determine exact results.

4. Use the point of the palette knife to make wires on the posts (shown in detail in Step Five). Don't force things, just let them happen. Add a few more sharp accents to contrast with the softness of the rest of the painting and to make this place the center of interest.

Texture the foreground with dark green. Add the bird if you like, but be sure not to make it darker than the fence.

Peaceful Corner
Zoltan Szabo 15" x 20"

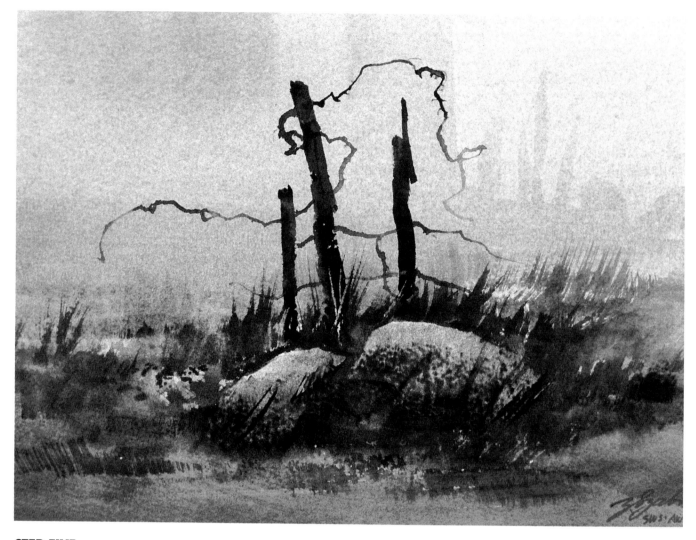

Detail: *Peaceful Corner*

STEP FIVE

Detail:

1. I thought you might like to see this area up close. To get the weedlike clusters behind the rock, flick up with the slant brush from the top edge of the rock. Flick the corner of the brush up and away. This will naturally taper the strokes to look like grass and weeds.

When I pulled out the wire with the palette knife, I didn't have a preconceived idea of where each stroke would be. I let one stroke lead into the next, and so on.

■ PROJECT 10: FALLING SNOW

Falling snow is one of the most compelling images for the painter—and one of the most elusive. When snow begins to fall, the distant background almost disappears as the air fills with falling flakes. The middle ground takes on a very soft look and colors become more neutral. To render the falling snowflakes, we will use table salt sprinkled on the wet wash of color. This painting was done on 400-lb. paper.

To make the salt work effectively, choose your pigments carefully. Many paints, in particular the staining and opaque colors, do not respond very well. Because I needed a few simple colors that would be neutralized and subdued, and colors that work with the salt, I chose the following:

Burnt sienna. Mixed with French ultramarine blue, makes a neutral gray base that will be very useful for a snow scene. And it responds well to salt.

French ultramarine blue. A warm blue that will balance the Antwerp blue.

Antwerp blue. A cool, transparent blue that will be used to make the greenish colors in the foreground. It stays clean, retaining its purity and brilliance in dark mixtures.

Raw sienna. A neutral yellow that is too pure for snow but will be a handy accent in the foreground.

Permanent rose. The only red on the palette. Just a touch will be used for the sky and some trees.

STEP ONE

Background:

1. Begin by wetting the whole paper using the wide, soft bristle brush. Since you want to keep the colors wet as long as possible, especially when it is time to use the salt, use a very heavy weight of paper (such as 400-lb.) to hold the moisture longer.

2. Mix burnt sienna and French ultramarine blue to make a cool blue gray of middle value, and apply it unevenly to the sky area with a 2-inch soft brush. Add a touch of grayish purple mixed from permanent rose and French ultramarine blue, and brush it into the still-wet color. Add a warm touch of raw sienna. Leave some brush strokes visible to represent rolling clouds.

3. Next, working quickly while the paper is still wet, make a warm gray from raw sienna, French ultramarine blue and burnt sienna, and use the 2-inch slant brush to paint in the ridges of the mountains. While the color is still wet, make some pine tree shapes to impart a sense of scale. To make the shapes, use the bristles of the long end of the slant brush. Just as the paper is losing its glisten, sprinkle salt lightly over the color. Drop the salt from about one foot above. It will bounce unevenly. Avoid making hot spots from clusters of salt grains. When the wash is still wet but has lost its glisten completely, sprinkle on more salt to make smaller flakes.

4. Let the color dry. It will take ten minutes for the salt to show its effects. If you are dissatisfied with the results, you can also splatter the picture with an opaque white such as gouache or casein. Don't use Chinese white; it is too blue.

When the painting is completely dry, brush off the salt.

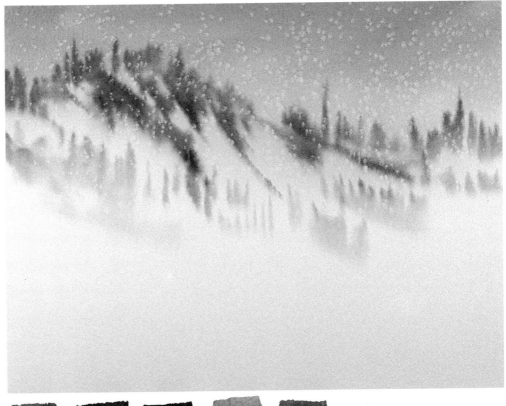

Burnt sienna French ultra-marine blue Antwerp blue Raw sienna Permanent rose

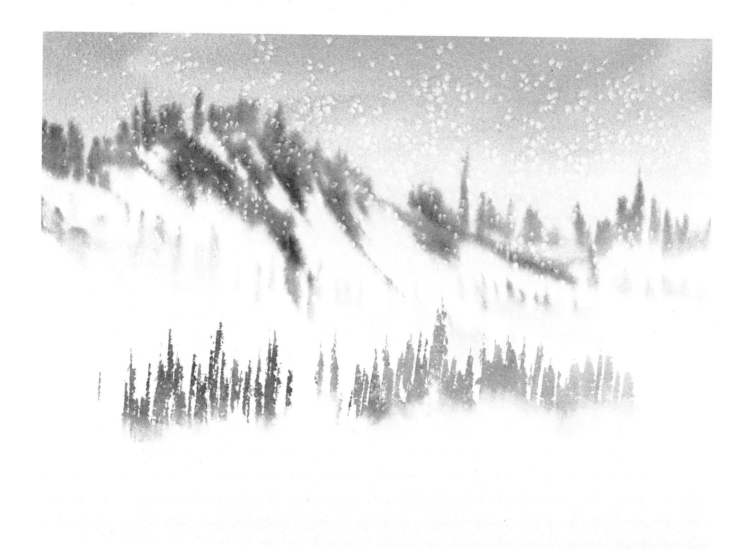

STEP TWO

Middle Ground Trees:

1. The middle ground consists of a layer of trees against the white "snow" of the paper. With a deeper, greener color mixed from French ultramarine blue and raw sienna, paint the pine trees by touching the long corner of the slant bristle brush to the paper and lifting upward. Lose the bottom edge by touching it with a clean, wet, small slant brush. Sprinkle a little salt while the color is still wet, as before.

2. Use the small rigger for individual trees and touches (such as the tips of trees) that need extra clarification. Remember only to suggest the trees; don't make them too tight. Let the paper dry thoroughly.

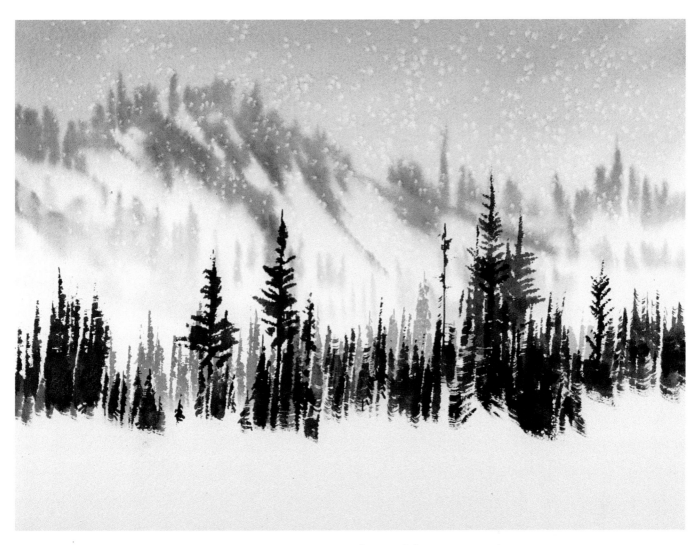

STEP THREE

Foreground Trees:

1. Mix a dark, neutralized color: start with some Antwerp blue and some permanent rose to make a purple base, then gray it with burnt sienna. With a medium wet brush, make tree shapes with the corner of the bristles; don't push too hard.

2. To add rich touches of color into the trees, dip the brush into the pure colors without mixing too much on the palette. Make the larger pine tree shapes bluer and darker at the base; let white sparkle through between the branches near the top, but just slightly near the bottom. Add more Antwerp blue and burnt sienna to the bases of the trees to get layers of snow hollows.

3. Vary the size of the trees to create depth, and soften some by blotting with tissues. A few "readable" trees individually made will make all the other trees more believable. Use the edge of the brush to create branches.

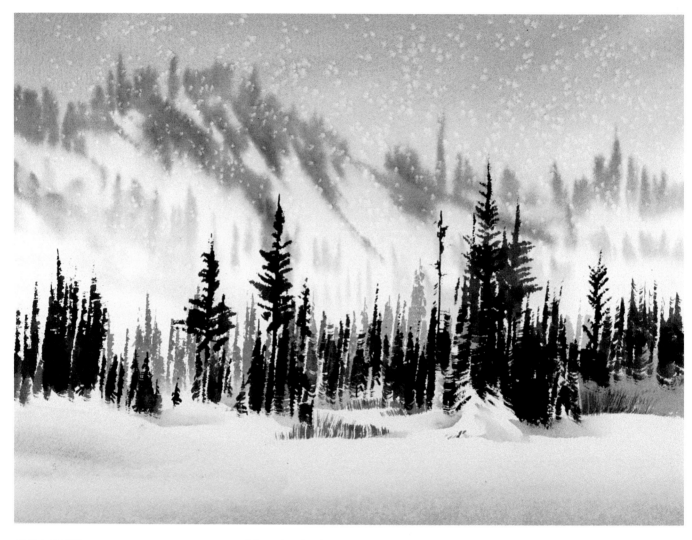

STEP FOUR

Foreground Snow:

1. Add mist to the base of the trees by applying a wash of grayed purple. Add weeds and shrubs with warmer color: mix burnt sienna and raw sienna, and apply the mixture with a dry brush technique of touching the tips of the bristles and stroking them upward for the undergrowth.

2. Paint the foreground snow, making it darker toward the bottom edge of the paper. Use the 3/4-inch soft, flat brush. Mix French ultramarine blue with a little raw sienna to reflect the cool of the sky. The top edge should be lost and soft; the bottom edge stays sharp. The gray makes the white in front of it stand out. Hint at the elevation of the background with a gray stroke painted over the shrubs.

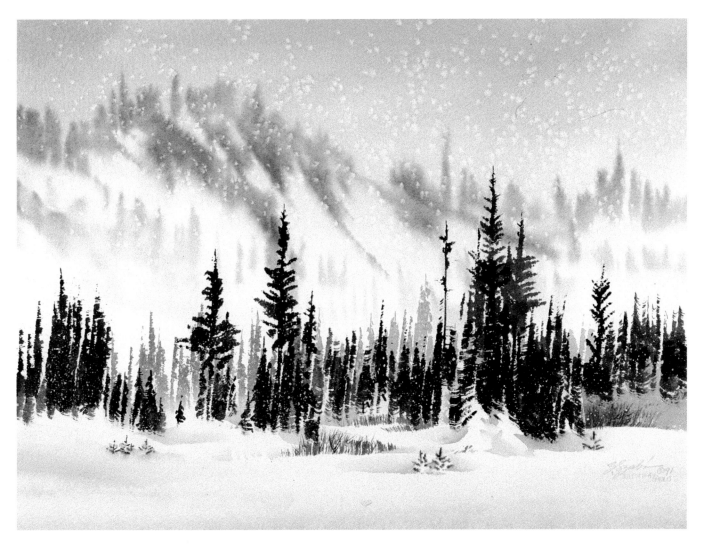

STEP FIVE

Focal Point and Splatter:

1. For a final touch, moisten the paper near the center of interest in the lower right, and add small, snow-covered trees. They should not be too obvious.

Mix some raw sienna and Antwerp blue. Before the shine goes, paint little designs of baby trees with the rigger brush. Young trees are more yellow than older, more mature trees. Leave white around them for snow.

2. Rewet the paper for the next few trees; they will be in small clusters, spaced for variety. Work with a wet-in-wet technique. Use rich color for the closer trees and a grayer one for the more distant trees. Then make the gray bluer, and paint the shaded tones behind the trees. Lose the top edge, making the trees look as if they were covered with snow.

3. One last step: Use the 1-inch slant brush, and splatter the foreground with white paint by pulling a finger across the bristles.

Cleaning Up
Zoltan Szabo 15" x 20"

■ PROJECT 11: MOUNTAIN SUNSET

My source photo for this painting was one I'd taken at the Grand Tetons. It was late afternoon, a good time to get beautiful light and shadow patterns. The tops of these mountains almost always have snow on them, making the light areas even brighter. Because of the importance of the light in this painting, it was very important to choose the right colors for my palette:

New gamboge and **alizarin crimson.** Staining colors that have the brightness I was looking for. They will be used for the lights.

French ultramarine blue. To be used for warm shadows.

Winsor blue. To be used for a darker, richer, deep violet shadow.

Burnt sienna. To be mixed with Winsor blue for a beautiful gray.

Sepia. The darkest value, for texture and accents.

STEP ONE

Sky and Sunlight:

1. In Project Eight, Still Water, you did the warm wash first. Here you are going to do the opposite—start with a cool wash for the sky. Wet the paper thoroughly and remove excess water by lightly (without pressure) going over the paper with a tissue. Make a mixture of French ultramarine blue, alizarin crimson, and a small amount of Winsor blue. Add a touch of burnt sienna to keep it from going too purple. Lay down a wash quickly, using a soft brush. Give the sky a feeling of movement in the wet wash.

2. Approximate the edge of the mountain. Don't make the edge even—it needs to look free and exciting. Remember, when you work from a photograph, or even from nature, you don't have to follow it exactly. I visually adjusted the contours of my mountains to make them more exciting.

The cool wash should be dark enough to add drama to the painting. You may need to remove the excess water from the tape around the edges so it won't bleed back into the picture.

3. Let the sky dry completely. In the area that is white in the illustration, do a warm wash to indicate the bright sunlight on the snow-covered slopes. Tilt your paper downward so the new color won't bleed into the blue. Wet the middle of your paper almost up to the blue. Now wash in a mixture of new gamboge and alizarin crimson in the space that is white. Get variety in your color by using a thirsty brush to soak up some color on the sunlit side. Clean your brush each time so the color doesn't go back onto the painting. *Go on to Step Two while this is still damp.*

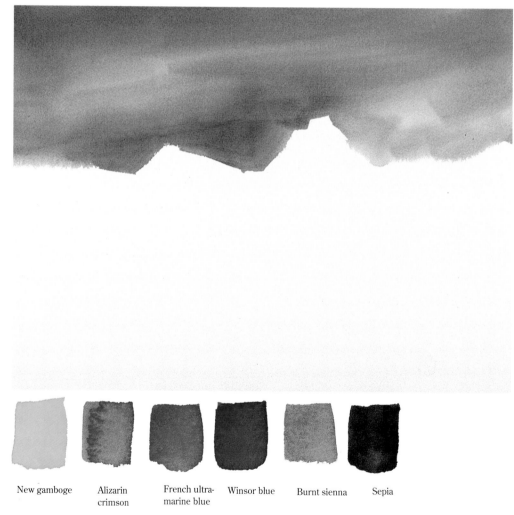

New gamboge Alizarin crimson French ultramarine blue Winsor blue Burnt sienna Sepia

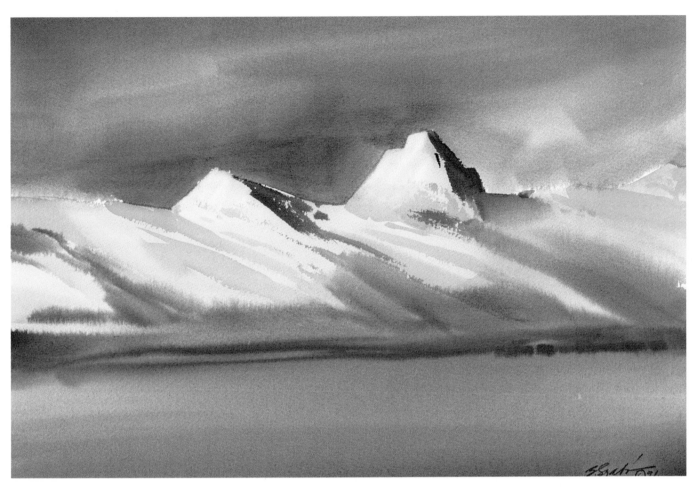

STEP TWO

Foreground and Variations on Mountain:

1. For the foreground, which I have decided to put in shade, use a mixture of French ultramarine blue, alizarin crimson, and a little burnt sienna. Add a touch of Winsor blue to go darker in a few places. Spread this color loosely, just like wetting the paper with a colored brush. While the sunlight color is still damp, paint a few slope shapes into the yellow mountains. Get a lot of contrast near the base of the mountain.

2. Now shape the shady side of the peaks. These shadows will have sharper edges than the sides of the slopes because they are sharp and rocky. Add these after the sunlight color has dried. This shadow needs to look very strong when it is wet because Winsor blue loses a lot of intensity when it dries. Work boldly with rich color.

3. Before adding landscape texture, lift off the areas of the peaks that should be the lightest. Don't forget this step. The color variations will add drama. Exaggerate this new value difference by adding a glaze of the same orange color as before, only a bit darker in value. Apply this glaze at the angle of the slopes.

Lose some of the bottom edges with a *clean* brush. Make sure you clean the brush well after losing each edge, because you are dealing with staining colors. These additions will appear to make the original wash lighter. Value can define a three-dimensional illusion much better than just color. With this approach you should be able to carefully paint successive glazes, going from the lightest value to the darkest.

4. Allow just a few dry brush touches for value and texture at the same time. Make sure your contrast is greatest where your focal point will be.

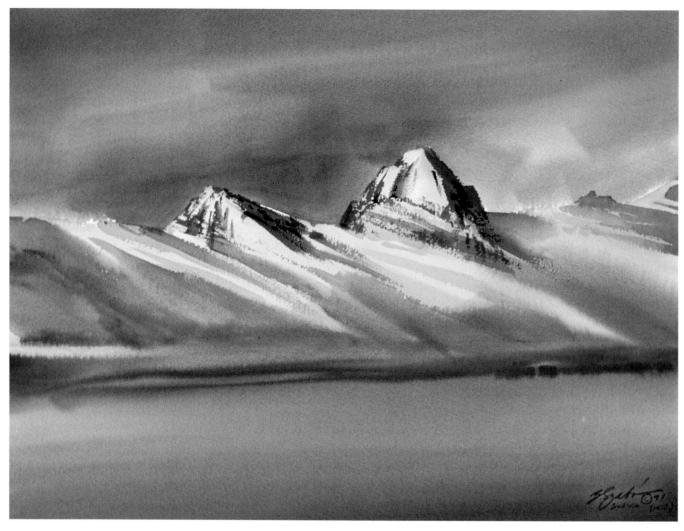

STEP THREE

Shading and Texture:

1. In this step you will create foliage and rocky textures. In the brightly sunlit area you will need to use a warm color. Mix a rich, deep reddish brown from burnt sienna, alizarin crimson and sepia. Starting on the peak on the right center, use small dry brush touches with a 3/4-inch flat, soft brush to develop characteristics of a rocky slope. Quickly dragged brush strokes give a good· dry brush effect. Don't try to paint everything exactly as it really was—it's impossible. Indicating and hinting these shapes and textures works best. Go right into the shadow with these textures. Use a small brush with sepia for dark accents both on the bright and shady sides.

2. The slopes will also get a bit of shaded modeling with French ultramarine blue and alizarin crimson. Play with the values within the shadow color to avoid a flat appearance. These long, glazed shadows add interest as well as contrast. Make sure your surface stays rich in color. Don't overdo the texturing.

3. One important aim in building up the shadow textures is to carve out your center of interest. My center of interest is the peak to the right of center. As I added shadow textures, I constantly was aware of the need to develop this focal point. At one point I noticed that the right edge of the paper was too strong and bright. I added shadow colors there to minimize the strength of what was a clear exit for the eye. As you do this step, move back and squint at your painting to see where it needs work. I also noticed that the left side was too bright, so I applied a darker glaze. Make sure the edges of these shadows stay soft, so the mountain blends into the foreground and isn't cut off like a stage backdrop.

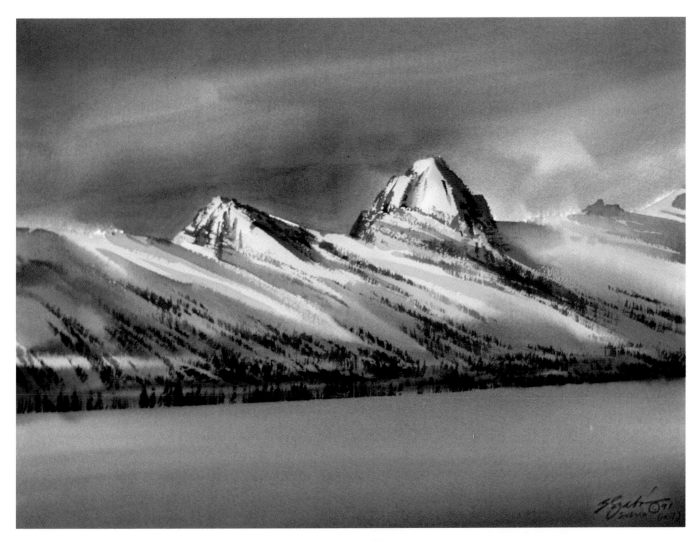

STEP FOUR

Decorative Elements:

1. In this step we will add some tree and foliage shapes. I call these "decorative elements" because they are surface elements that are added on top of the basic design structure we've already established.

2. Using your 1 1/2-inch slant brush with burnt sienna and a little new gamboge, carefully add some interesting tree shapes to the painting. Hold your brush at a correct slant so the trees go straight up, not at an angle. When you run out of paint, be sure to add more paint to your brush, not just more water. You need rich color for these touches. When you hit the sunlit areas, go to a warmer color—add some alizarin crimson and a little more new gamboge. You can see this at the baseline at the far left and on the center slope.

3. The foreground must have a unified texture to stay set back and not draw the eye from the center of interest. But you can add some interest in this area by using the following special effect: Put down masking or artist's tape as shown in the picture above. The surface must be totally dry and the tape must be straight. Make little brush marks going up from the tape, with the top of the

tape at the bottom of the strokes. When the tape is removed, these marks will appear as pine trees in a bluff.

This shows the foreground before I removed the masking tape.

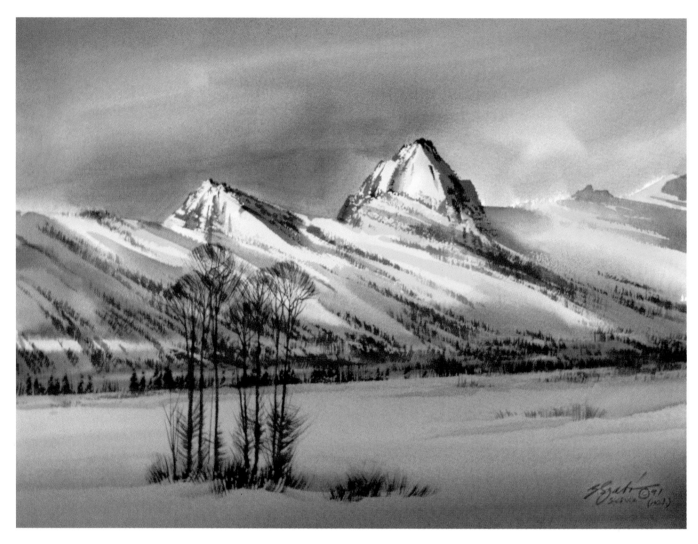

STEP FIVE

Foreground Trees and Finish:

1. We're going to add some cottonwood trees in the foreground to break up all of that dead space. This dark group of shapes will set off the mountains even more. Never put a decorative element like this in the dead center.

Use sepia, alizarin crimson and French ultramarine blue with your 1 1/2-inch slant brush. Use a dry brush calligraphic stroke for a cluster effect. Mix a liquid but dark hue to use with the palette knife for the tree trunks and branches.

Use dry brush strokes to pull the fuzzies out of the trunks. You can use a rigger to attach the tops of the trees to the supporting limbs. Don't rush this step. You have to take your time to make it look random.

2. Another finishing touch is to model the field of snow next to this clump of trees. The bottom edge will stay found, the top edge will get lost. When losing the edge, keep cleaning your brush before you put it in clean water. Make sure the calligraphy is flawlessly dry before painting on top of it.

Sun Scoop
Zoltan Szabo 15" x 20"

■ PROJECT 12: SPLASHING SURF

Hawaiian surf is very active. The roaring ocean crashes against the dark, angular cliffs of volcanic rock, creating wonderful contrasts of hard and soft shapes and light and dark colors. It is the contrast in this scene that makes painting it such a challenging and rewarding experience.

The colors you will use were chosen to enhance the contrasts in the subject. They are:

Sepia. A rich dark for contrast. It can be textured well with the knife.

Antwerp blue. A dark, transparent blue that will contrast with the surf's spray.

Permanent rose. A cool, transparent red useful for creating warm contrasts.

Cobalt turquoise. A beautiful, opaque blue green.

Aureolin yellow. A soft, quiet color that you will need in large quantities because the other colors are so much stronger.

Burnt sienna. A versatile workhorse that will be used to make darks. When mixed with aureolin yellow, it makes a color very much like raw sienna.

You will be surprised how the values of the blues will dry lighter, so do not be afraid to use rich, dark mixtures of paint.

STEP ONE
Sky:

1. Begin by wetting the paper thoroughly with a large, wide, soft brush. Paint the sky with a soft, flat 2-inch brush, using a rich mixture of cobalt turquoise, Antwerp blue and permanent rose. Paint around the waves and mist, leaving them as negative shapes.

2. Add some yellow to the mixture for a touch of green in the overall blue sky. Play with the edges so they stay soft. Any edges the brush leaves may be used later. Try to keep the sky active with loose strokes. Gradually darken the edges, letting them diffuse as gravity pulls the edges into the softer shapes.

3. We often misjudge the color in the waves as either white or dark water. It is a deeper, richer, warmer color near the bottom. Add more green to the spray. Finally, splatter some clear water into the drying green just as the color loses its shine.

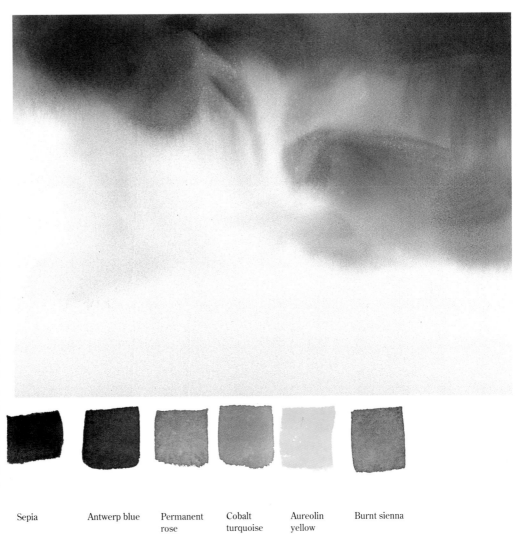

Sepia Antwerp blue Permanent rose Cobalt turquoise Aureolin yellow Burnt sienna

STEP TWO

Painting Details in the Water:

1. Use masking or drafting tape to establish the horizon line. Mix a dark, deep color of Antwerp blue and a bit of burnt sienna for the slightly greenish color of the distant water. Pull your brush horizontally with the tape, and remove the tape while the color is still wet. Then continue extending the wash of color downward. Where the horizon is obscured by the surf and its spray, soften and lose the edge, making a gentle transition.

2. Use cobalt turquoise and aureolin yellow for the rolling surf near the far right center. Vary the dominance and add touches of dark, warm blue for variety. Move and roll the brush in the same direction as the wave rolls.

3. To make the rough edge of the surf in the foreground, use a flat, soft 2-inch brush and a mixture of permanent rose, aureolin yellow and cobalt turquoise. Lightly pull the brush back and forth over the surface of the paper so it just touches the surface with its flat side.

4. Add touches of orange for details on the left by mixing a warm grayish orange from the cobalt turquoise and burnt sienna.

STEP THREE

Rock Textures:

1. Keep the palette knife and the small slant brush handy. Mix a very strong, dark mixture of sepia, a little Antwerp blue, and a touch of permanent rose. Dip the slant brush into the paint so the color is on the corner with the longer bristles. Paint the edge of the rocks with that corner, making a hard, contrasting line on one side and a softer, lighter edge on the other. Lose the color into the wave with a thirsty edge of a clean brush. Reinforce the hard edge of the rocks with more paint for a sharp, crisp line.

2. While the rock color is still damp, scrape it with the heel of the palette knife, leaving hints of texture. Add a second layer of color for the next tier of rocks; use a dark mixture of sepia, Antwerp blue for its transparency, and permanent rose for its warmth and color. Add darker and darker colors as the layers of texture dry, adding touches of burnt sienna for variety. For the small rocks along the bottom, use a dry brush technique to create a bro-ken, almost lacy, look.

3. With sepia and burnt sienna, make a mosaic of detail on the rocks with the small, flat brush. Flash some green in the turbulent water. Add the third layer of rocks with a dark made of sepia and burnt sienna. Knife in the texture. The nearest rocks get very heavy texturing with the knife. Add a glaze of green over the lighter areas of the rocks. Additional modeling will make some rocks appear to be hiding behind other rocks.

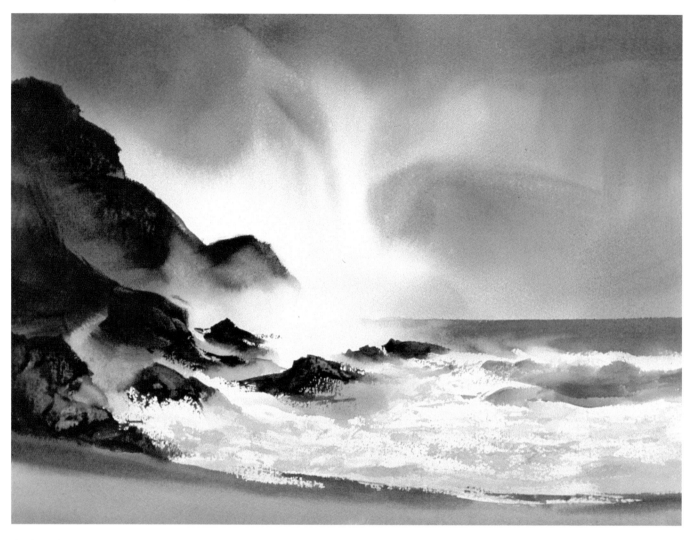

STEP FOUR

Foreground:

1. Mix permanent rose, aureolin yellow, and a touch of sepia (as an accent) to make an orange, and apply it with a large, flat brush where the sand appears in the foreground. Add a touch of dark gray where the waves left reflective surfaces. Use a dry brush technique for the top edge.

2. Use some burnt sienna and a bit of gray where the rocks make the transition into the sand on the far left. Adjust the shape of the rock formation, breaking up any edges that are too perfect or boring. (No turtles, please!)

3. Now paint the edge of the rolling wave on the right with a deep greenish color made from Antwerp blue, cobalt turquoise and burnt sienna.

4. Use a dry brush and lost edges for blending touches. Too much white can create dead spots, so vary the color of the shapes on the right. Add a few more rock shapes to prevent them from ending too close to the center.

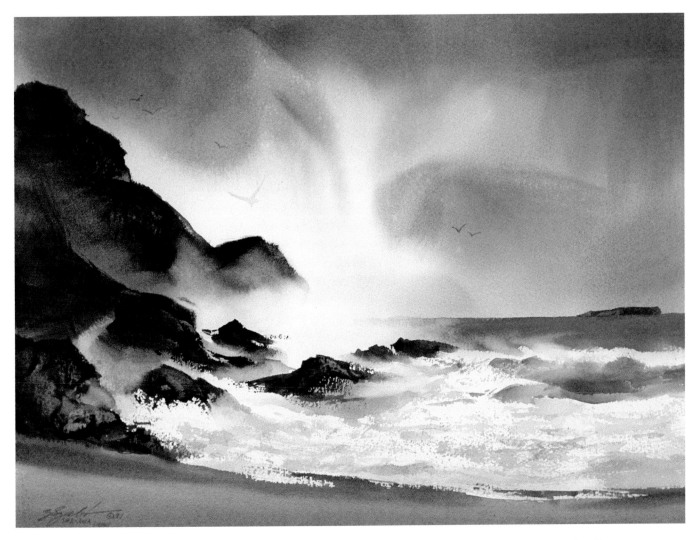

Unintended Shower
Zoltan Szabo 15" x 20"

STEP FIVE

Finishing Touches:

1. To add interest to the long, straight horizon line, paint a small island in the distance. It adds balance to the composition and acts as a "blocker," preventing the eye from wandering out of the composition. Use a mixture of burnt sienna, Antwerp blue and permanent rose, and apply it with the small round rigger. Be careful that it doesn't become too dark or too large.

2. Use the rigger to paint the bird getting the unexpected shower. Add a few more birds for accents. At this point you should assess your painting's composition for any flaws. I decided my painting needed some additional work in the foreground. I made a gray mixture of permanent rose, sepia and aureolin yellow and used the 2-inch slant bristle to add the glaze to the bottom of the composition. I softened the edge toward the top.

■ SUPPLEMENTARY PHOTO SOURCES

Please read my comments in the introduction regarding using these photos. Drawings for these are found on the following pages.

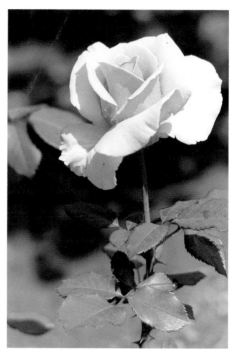

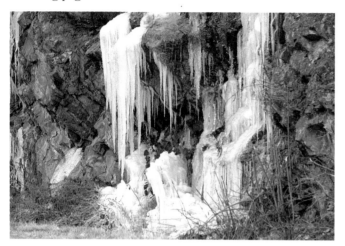

This goes with Project One—Icicles.

This goes with Project Two—Azaleas.

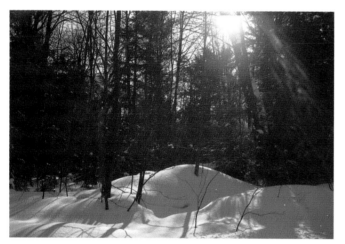

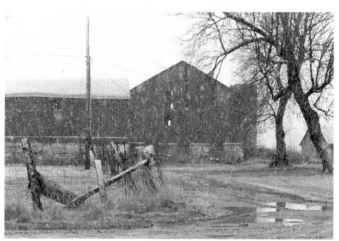

This goes with Project Three—Moonlight on Snow.

This goes with Project Four—Puddle Reflections.

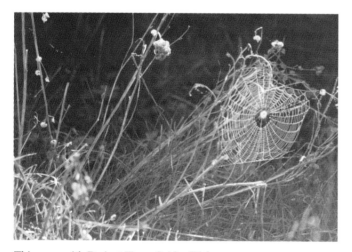

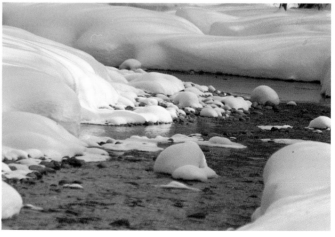

This goes with Project Five—Spider Web.

This goes with Project Six—Snowy Creek.

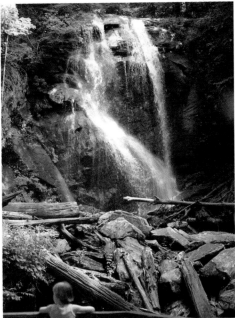

This goes with Project Seven—Waterfall.

This goes with Project Eight—Still Water.

This goes with Project Nine—Distant Mist.

This goes with Project Ten—Falling Snow.

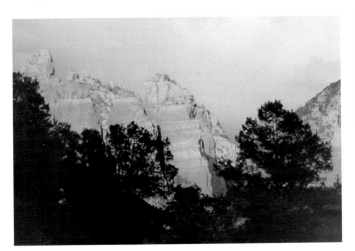

This goes with Project Eleven—Mountain Sunset.

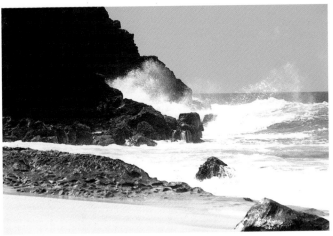

This goes with Project Twelve—Splashing Surf.

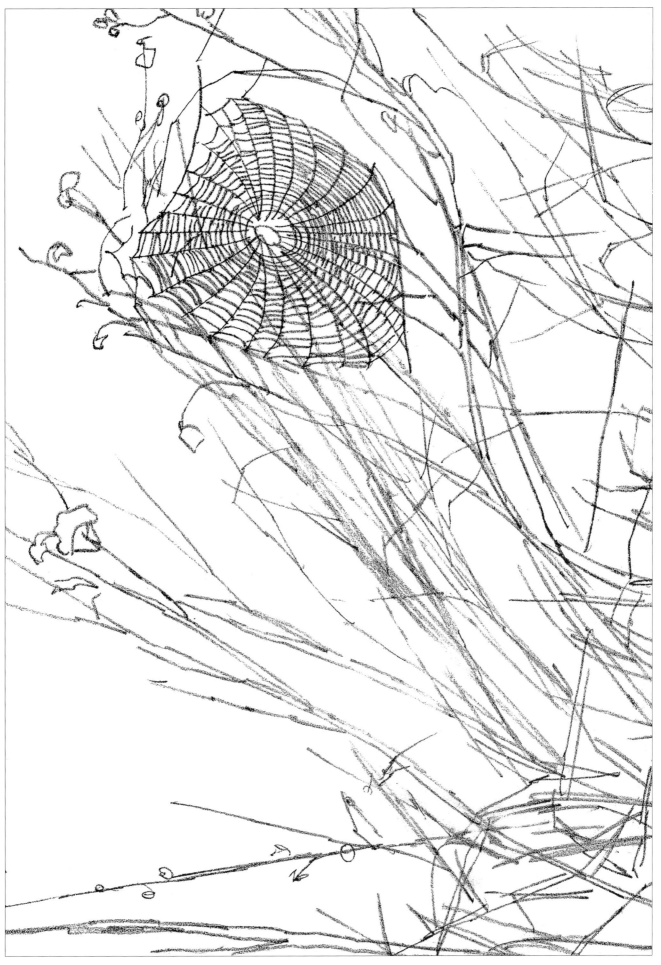

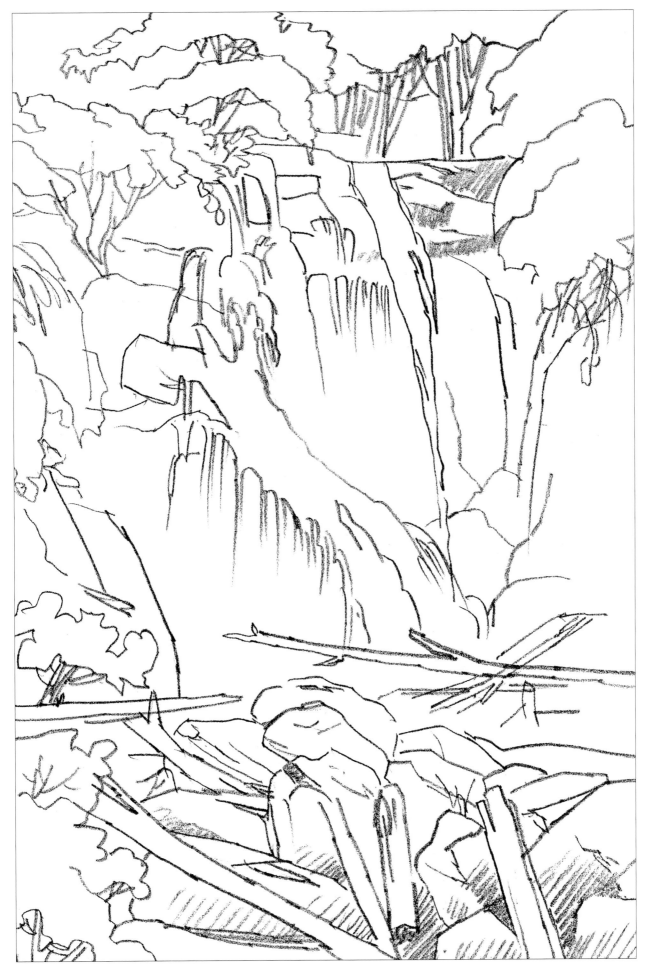

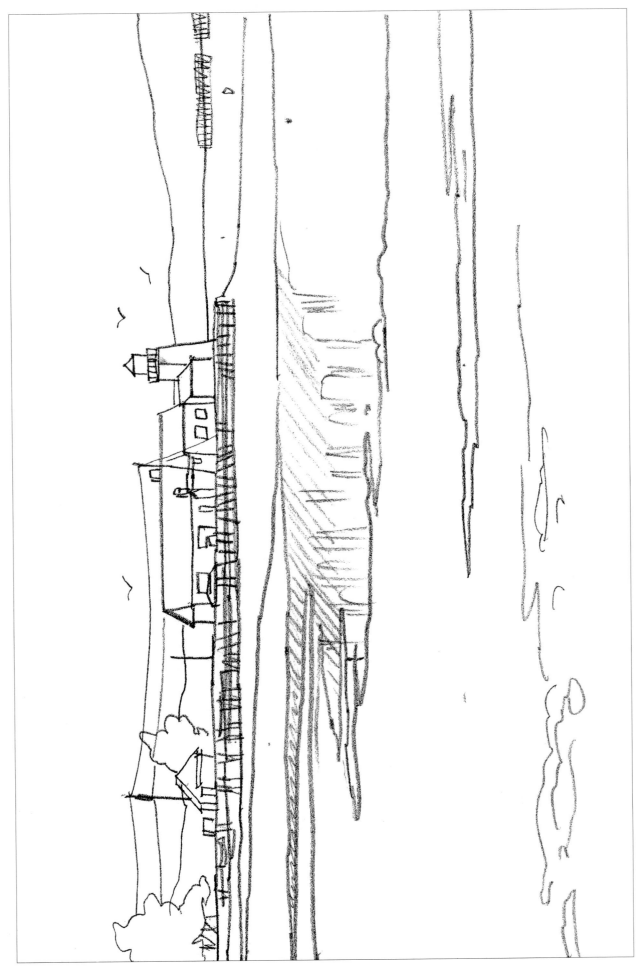

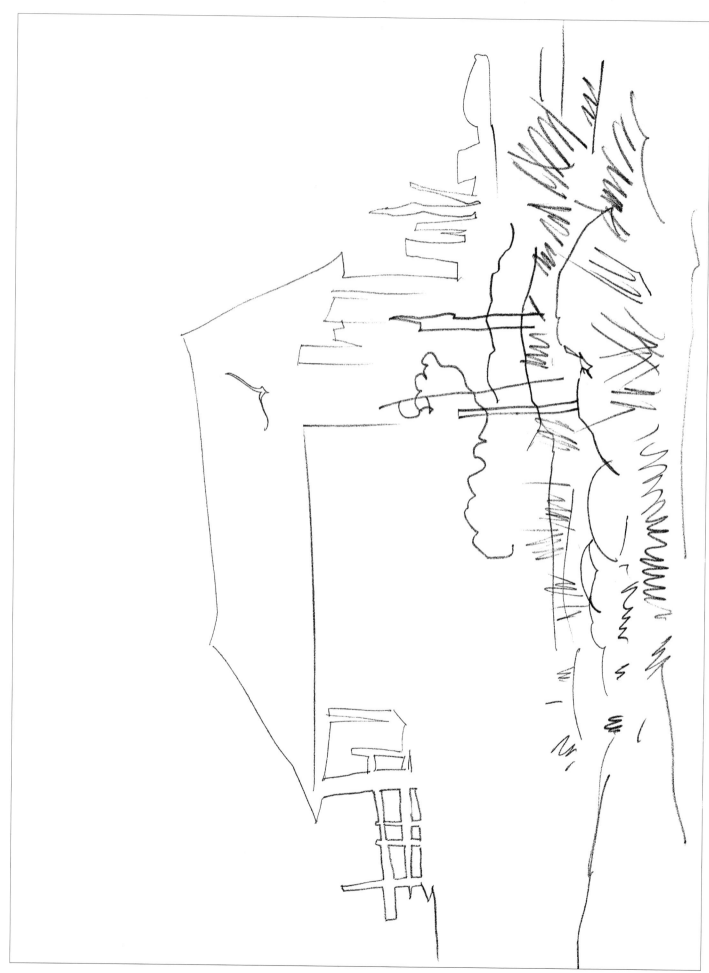

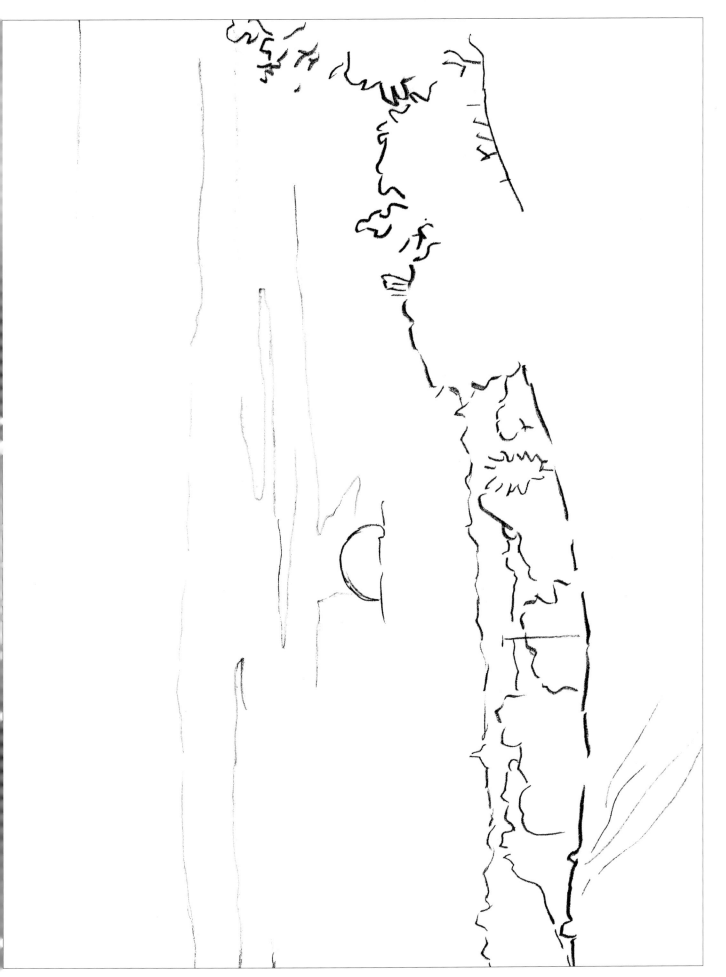

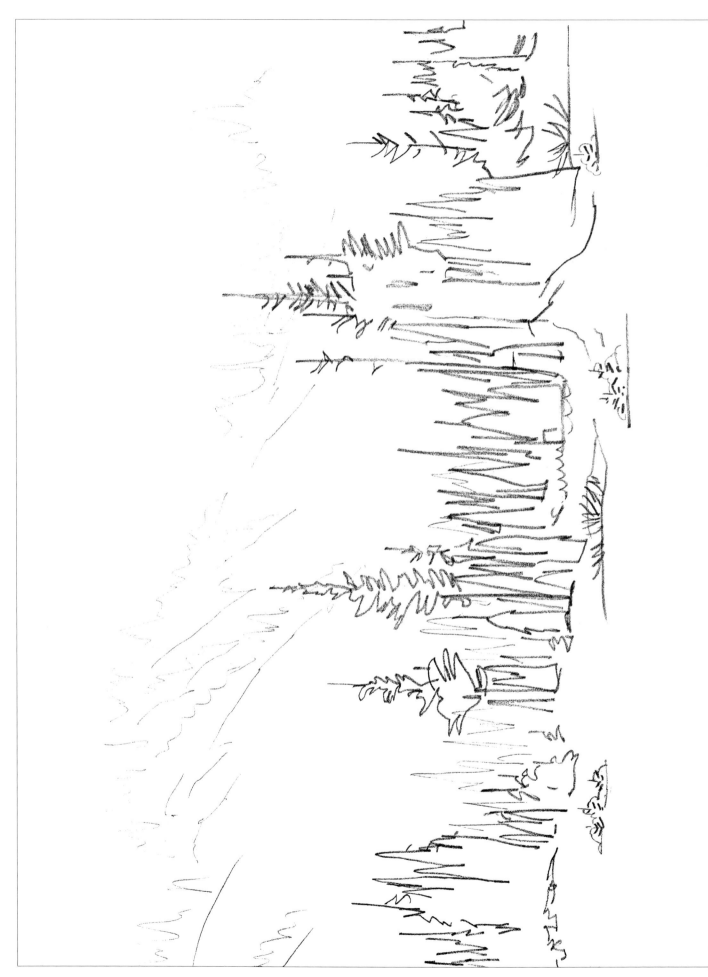

■ INDEX